Revolutionary States:
Home Rule and Modern Ireland

D1428428

REVOLUTIONARY STATES:
HOME RULE & MODERN IRELAND

Dublin City Gallery The Hugh Lane

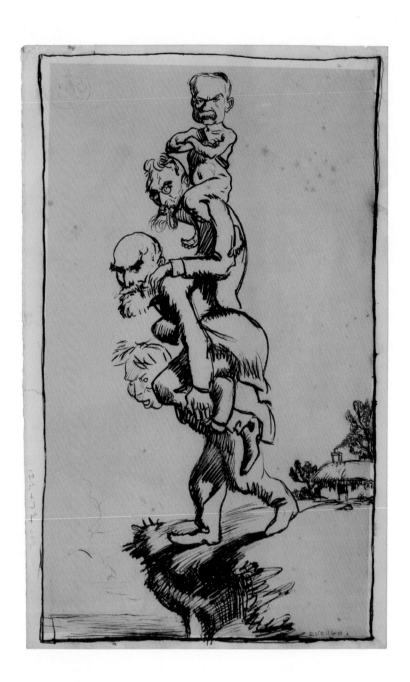

Sir William Orpen
Enough!, c.1905
Orpen carries on his shoulders, from top to
bottom, Lord MacDonnell, William O'Brien
and Michael Davitt.

Contents

Minister's Foreword

Jimmy Deenihan, TD
Minister for Arts, Heritage and the Gaeltacht

This decade of centenaries presents an opportunity for us to reflect on the experience and achievements of a remarkable era and as part of this programme, I am delighted that Dublin City Gallery The Hugh Lane has assembled this outstanding exhibition to commemorate the introduction of the Third Home Rule Bill and the events which unfolded in the years that followed.

There could be no better place for this Home Rule exhibition than the Gallery established by Hugh Lane 104 years ago. Hugh Lane's championing of Modern and Impressionist art and his gift of some world-class works to Ireland (as the Home Rule movement gathered momentum) continue to enrich our lives more than a century later. Indeed, we will appropriately commemorate the centenary of the tragic death of Hugh Lane and the others who lost their lives on the Lusitania in 1915 as part of our commemoration programme.

The Home Rule movement, from Horace Plunkett and Michael Davitt, through Parnell and Redmond, the Unionist leaders Carson and Craig, and all of the men and women who supported and opposed them, shaped the island of Ireland and our relationship with Britain. Indeed, the last vestiges of the Government of Ireland Act (alias the Fourth Home Rule Bill) were repealed only after the ratification of the Good Friday Agreement. Even today, the legacies of Home Rulers and Ulster Covenanters teach us much about ourselves and inform the ongoing process of reconciliation in the North.

The effusion of time insulates us from the contrasting passions of that momentous period in Irish history, enabling us to cast a more objective eye on figures and events.

It makes the respective positions of those involved no less potent, but it can also make it harder to identify with their motivations and passions. This exhibition offers a unique opportunity to connect in our minds the resonant words of Redmond and Carson, Davitt and Lord MacDonnell, Yeats and Hyde and to link them with images of the men themselves, as depicted by the outstanding artists of the time.

Similarly this exhibition assembles a collection of landscapes that offer differing perspectives on daily life in Ireland, as Home Rule was being debated at Westminster. Some artists romanticised and idealised, while others presented a gritty realism of manual labour. Others chose satire or symbolism to capture elements of how the nation saw itself, or was seen by others. This exhibition brings together this range of visions, and allows visitors to assemble a composite impression of what the Ireland of the time really *felt* like.

I would like to conclude by thanking Dr Barbara Dawson, Director of Dublin City Gallery The Hugh Lane, Mr Logan Sisley, curator of the exhibition, Mr Michael Dempsey, Dr Margarita Cappock, and all at Dublin City Gallery The Hugh Lane and the Ulster Museum whose co-operation and diligent work has made this exhibition possible.

Lord Mayor's Foreword

Andrew Montague
Lord Mayor of Dublin

Dublin City Gallery The Hugh Lane is marking the centenary of the introduction of the Third Home Rule Bill with an exhibition exploring the political and cultural events surrounding this significant milestone. The City's Gallery is uniquely placed to tell, through its collections, the story of the turbulent and complex period in Ireland prior to the First World War.

The establishment of the Municipal Gallery of Modern Art in Dublin in 1908 was the most important event in the visual arts in Ireland in the early twentieth century. The Gallery was central to debates around Irish cultural identities, and its collection – one of the city's great treasures – includes portraits of many of the key figures who worked in support of and in opposition to Home Rule. As we reflect on the years prior to the foundation of the State, it provides an invaluable record of the period.

The Home Rule movement and the opposition to it developed in parallel to the other social and political movements such as the suffragette and labour movements and those agitating for land reform. 1912 also marks the centenary of the election of the first woman to Dublin City Council – the artist, Sarah Cecilia Harrison, one of the key figures in the foundation of the Gallery of Modern Art.

Hugh Lane and many of his supporters envisaged the Gallery as a meeting place for those of different political, social and economic backgrounds. More than a century later, Dublin City Gallery The Hugh Lane remains a free cultural amenity for all citizens of Dublin and visitors alike.

I wish to express my gratitude to the Department of Arts, Heritage and the Gaeltacht for its support of *Revolutionary States: Home Rule and Modern Ireland* and to all of my colleagues in Dublin City Council who have worked to make this exhibition possible.

A Decade of Commemorations

Barbara Dawson

Director, Dublin City Gallery The Hugh Lane

The proposed decade of centenary celebrations from 2012 to 2022 will encourage us to look ourselves in the eye and direct our attention to our past, to one of the most momentous periods of Irish history, when, to a backdrop of cultural enlightenment and the rise of modernism in Europe, self determination and national identity came to the fore in Irish politics. In 1912, after thirty years of endeavour, John Redmond and the Irish Party successfully saw the Third Home Rule pass its second reading in the House of Commons in May. By September, opposition to Home Rule brought the signing of the Ulster Covenant, which polarised Irish society and politics for decades to come.

Throughout 1912, controversy raged over finding a suitable site for the Municipal Gallery of Modern Art (established in 1908 in a temporary location, Clonmell House, Harcourt Street). The sites identified were rejected as either unsuitable or unavailable. In an effort to resolve the problem, the architect Edwin Lutyens proposed building a gallery across the Liffey, replacing the Ha'penny Bridge. Dublin Corporation narrowly voted against the site (which, if it had gone ahead, would have most probably been blown up by the British army boats during the 1916 Rising). However, no alternative was presented and in November Lane gave the city an ultimatum either to identify a site or else he would remove his 'Continental Pictures'. It took him another year to carry out his threat. Removing his pictures irrevocably changed the Irish cultural landscape and his hopes of creating a climate to support a modern vibrant Irish art practice were thwarted.

These commemorations allow us the opportunity to plumb the archives of our past. The findings will enhance our understanding of what was undoubtedly an illuminating but turbulent time, the complexity of which will not succumb to one easy or simplistic reading. The passing of the Third Home Rule Bill pointed to a new era in Irish politics; the establishment of the Municipal Gallery of Modern Art in Dublin in 1908 was the most important cultural event of the time. As George Russell (Æ) always argued, Ireland is not a society unified by one culture but rather it is made up of a synthesis of cultures. It is this plurality that makes these commemorations so significant.

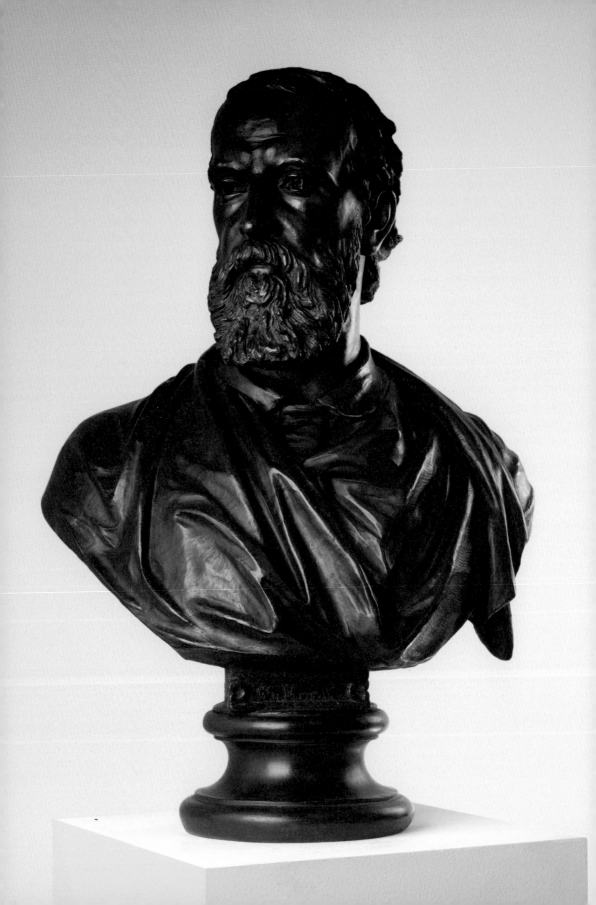

Revolutionary States

R.F. Foster

'Ireland is being made', wrote W.B. Yeats to his friend the theatre designer Gordon Craig early in 1913, 'and this gives the few who have clear sight the determination to shape it.'[1] Yeats was writing about a Dublin exhibition of Craig's revolutionary set-designs, but he was also referring to a range of cultural, political and artistic controversies which had been convulsing Ireland over the previous year. This exhibition, a century later, reflects and illustrates that moment when Ireland was 'being made': it also reminds us that the way it turned out was not how many of its most prominent 'makers' would have anticipated.

This is because the political realities and expectations of 1912 revolved around the Home Rule moment. After decades of agitation, controversy, defeats and renewed hopes, the campaign for an autonomous Ireland with its own parliament seemed at hand. This was the ideal fought for by Charles Stewart Parnell before his shattering fall and death in 1890/91, adopted by W.E. Gladstone as part of Liberal party policy (a step which split the party irrevocably), and sustained by Parnell's eventual successor as Irish party leader at Westminster, John Redmond. It was introduced on 11 April 1912 in the House of Commons – and could no longer (since the Parliament Act of the previous year) be summarily rejected by the Lords, as had happened in 1893. A moment of high political excitement seemed to be reflected in the cultural achievements – theatrical, literary, artistic – for which Ireland had become celebrated since the turn of the century. 1912 also seemed to be a moment when, after centuries of inequality, poverty and misgovernment, the country seemed

Mary Grant
Charles Stewart Parnell, 1892

1 Quoted in R.F. Foster, *W.B. Yeats, A Life, I: The Apprentice Mage, 1865–1914* (Oxford, 1997), p. 482.

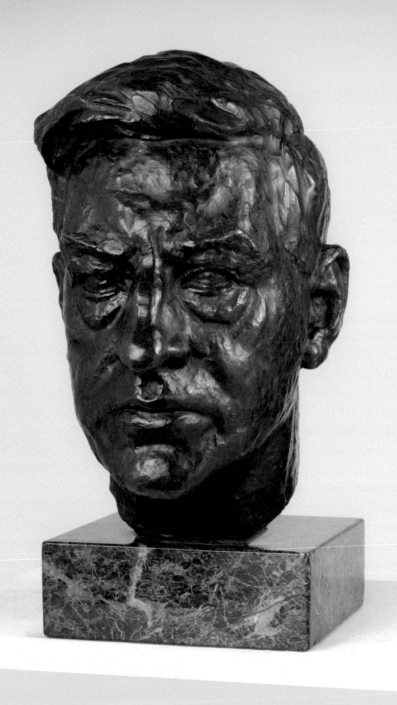

to be achieving prosperity and social confidence, and this apparently betokened a new relationship with England. Redmond himself stated as much in a speech at Wexford in October 1914:

> People talk of the wrongs done to Ireland by England in the past. God knows, standing on this holy spot it is not likely any of us can ever forget, though God grant we may all forgive, the wrongs done to our fathers a hundred or two hundred years ago. *But do let us be a sensible and truthful people.* Do let us remember that we today of our generation are a free people (*cheers*). We have emancipated the farmer; we have housed the agricultural labourer; we have won religious liberty; we have won free education… we have laid broad and deep the foundations of national prosperity and finally we have won an Irish parliament and an executive responsible to it (*cheers*).[2]

By 1914 Redmond desperately needed to emphasise these points, as he was defending his decision to support the war against Germany. But at the time of the 1912 Act, much that he claimed had indeed come to pass. Land reform had been imposed through a series of Land Acts enabling Irish farmers to buy out their holdings at increasingly favourable rates, with government aid: climaxing in the 1903 Act created by George Wyndham. Liberal-minded government officials such as Antony MacDonnell and landlords like John Shawe-Taylor had co-operated with radical politicians such as William O'Brien, first to draft land reform, then (less effectively) to float ideas of political devolution, through co-operation between unionists and nationalists. A National University had been founded, with a strongly Catholic ethos. In politics as in culture, there was a sense of old limitations being transcended and ancient barriers being broken down.

But simultaneously other fortifications were being thrown up. The previous decade had seen high-octane controversies over the power of the Catholic church in Irish life, the place of the Irish language in the Irish educational system, and the ethos of that new National University. The confrontation between labour and capital would burst into the Dublin streets in 1913, with the lock-out of members of the Transport and General Workers' Union, led by Jim Larkin. And the most ominous battlement of all was being erected around Ulster.

Mina Carney
Jim Larkin, n.d.

2 *Weekly Freeman's Journal*, 10 October 1914, as quoted in Paul Bew, *Ideology and the Irish Question: Ulster Unionism and Irish Nationalism 1912–1916* (Oxford, 1994), p. 123.

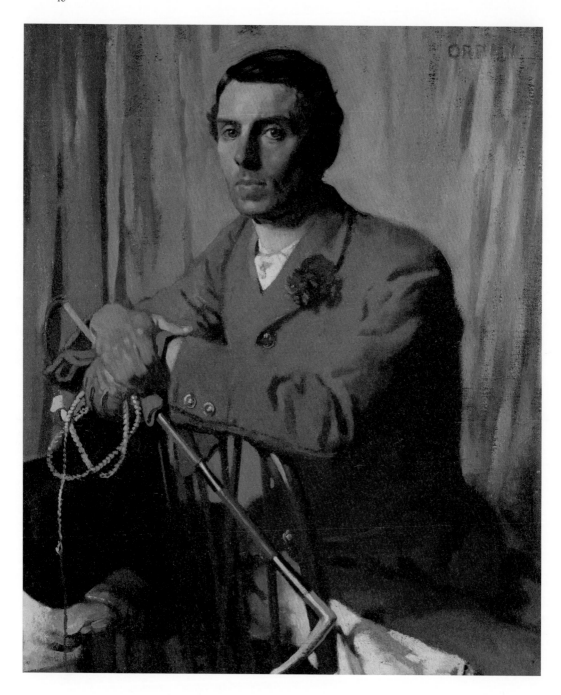

Sir William Orpen
Captain Shawe-Taylor, 1906

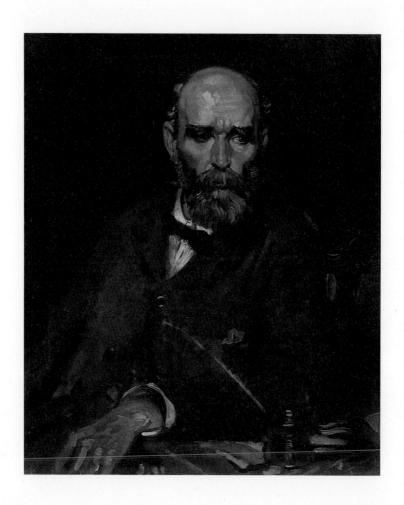

Sir William Orpen
Michael Davitt, MP, 1905

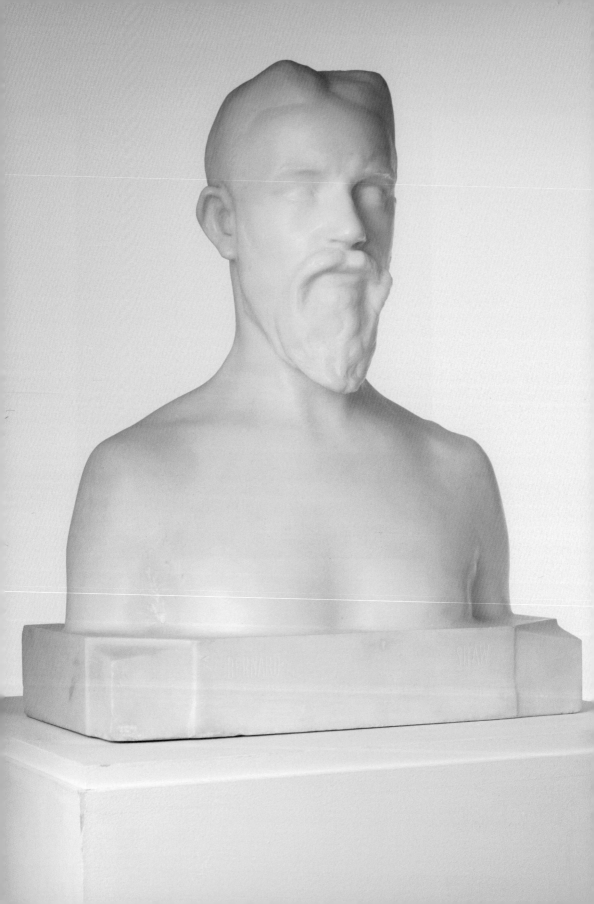

The resistance of the Protestant unionists of the north-eastern counties to rule from a parliament in Dublin dominated by Catholics and nationalists was taking shape before the Home Rule Bill was introduced, and the events of 1912 crystallised it, with the foundation of the Ulster Volunteer Force pledged to resist Home Rule in arms, and the emergence of the Dublin lawyer Edward Carson as their leader. While Liberal politicians such as Lloyd George and Winston Churchill affected to dismiss this as bluster, in 1912 too the first mentions of partitioning Ireland began to gather shape. Within a year, the nationalists in the rest of the island would form their own National Volunteers to protect Home Rule – and both organisations would determine to arm themselves. In retrospect we can discern the acceleration of tempo which would climax in the importation of arms and ensuing clashes with Crown forces in 1914, the advent of European war, and the insurrection of 1916.

But all this was in the future when Home Rule was finally – as it seemed – brought into political being in 1912. While the measure was considered excessively mild and cautious by 'advanced nationalists', even radical journalists like Arthur Griffith, the founder of Sinn Féin, found it hard to argue against it as a step on the way. Others who had been hot Fenians in their youth, like Yeats himself, gave it firm support. For Yeats and many others, the politics that now mattered could be summed up as cultural independence from Britain, an opening up to European influence, and the ability to build new ways of thought and seeing, through literature, drama and visual art. By 1912, the new vision of Ireland which he had pioneered from the 1890s onward was well established; not only in the heroic imagery of an ancient culture, reinvented by the history-stories of Standish O'Grady and the Cúchulainn-myth popularised by Yeats's own plays, but in the contemporary cult of the West of Ireland, immortalised in Jack B. Yeats's visionary paintings and drawings, and the heroic portraits later produced by Seán Keating.

Another form of cultural influence emanating from the West comprised the annual gatherings of writers, artists and cultural entrepreneurs at Coole Park, Lady Gregory's house near Gort, County Galway; regulars included Yeats, his brother Jack, the painter, philosopher and co-operativist George Russell (Æ), the playwrights J.M. Synge and George Bernard Shaw, and Douglas Hyde, founder of the Gaelic League. From such a meeting had emerged the Irish Literary Theatre in 1899, and eventually the Abbey Theatre in 1904.

François-Auguste-René Rodin
George Bernard Shaw, 1906

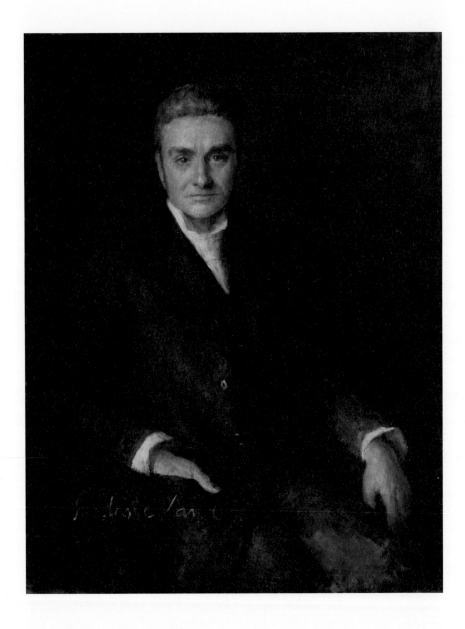

John Butler Yeats
Standish O'Grady, 1904

Patrick Joseph Tuohy
Flight of Cúchulainn, c. 1919
This illustration by Tuohy was used as the
frontispiece for the 1920 edition of Standish
O'Grady's *The Coming of Cuculain*, published
by Frederick A. Stokes, New York.

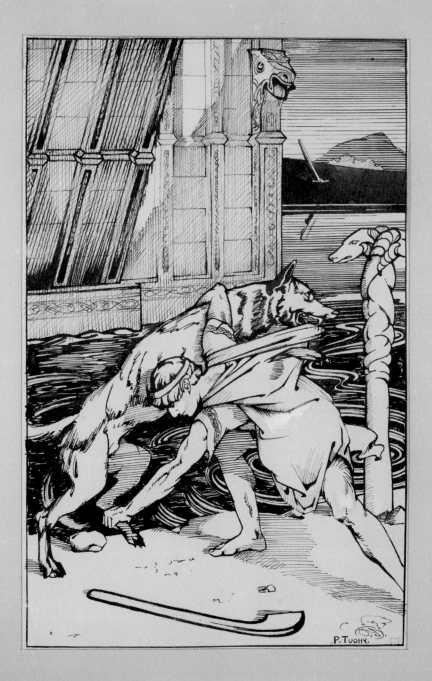

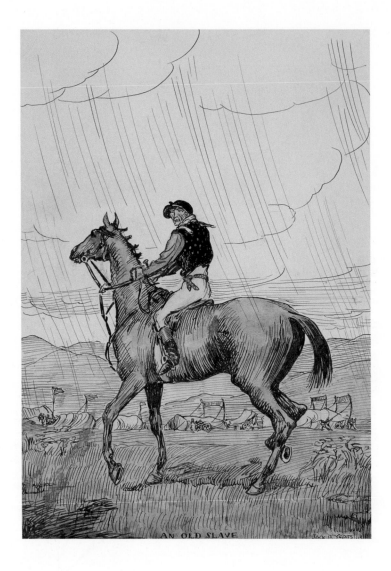

Jack B. Yeats
An Old Slave, c. 1911

Seán Keating
An Aran Fisherman and his Wife, 1916

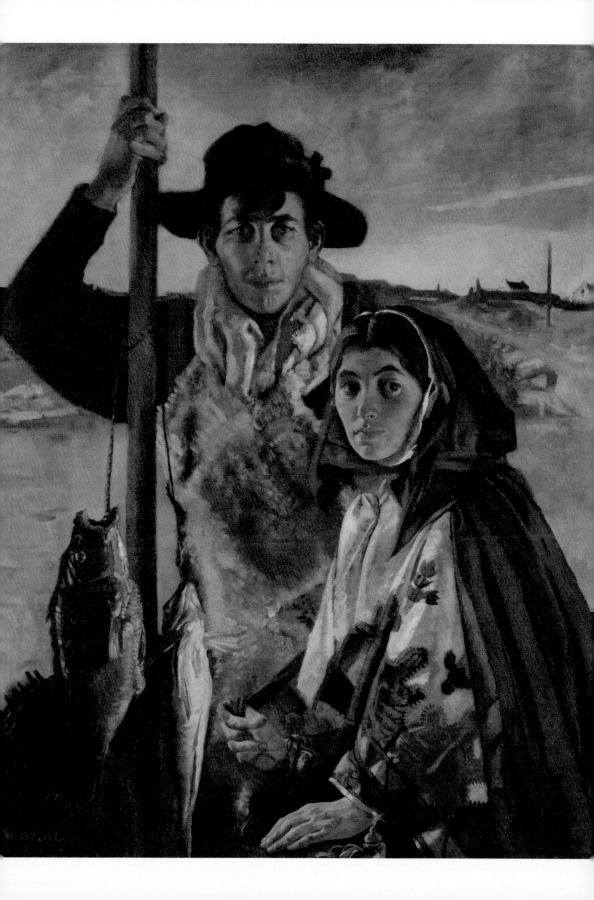

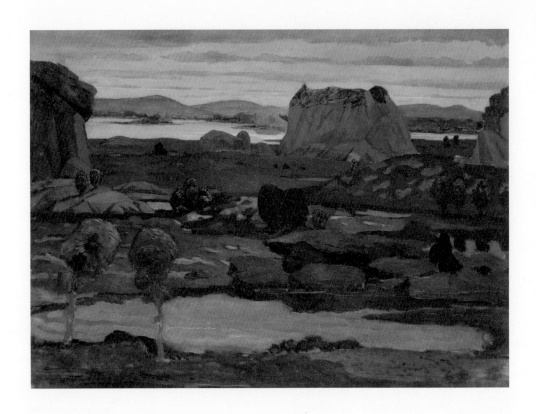

Robert Gregory
Coole Lake, c. 1914

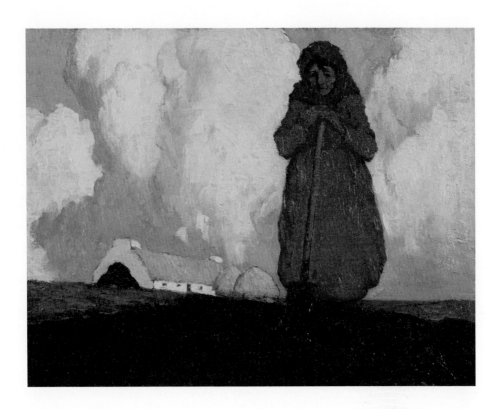

Paul Henry
The Potato Digger, 1912–15

By 1912 the Abbey had lived up to Martin Esslin's dictum that the theatre is where a nation 'thinks in front of itself'.[3] Dominated in its formative years by Yeats, Lady Gregory and J.M. Synge, it was now established as an avant-garde institution, touring successfully in America and Britain, and occupying a central place in Dublin's cultural life. The city was famously quarrelsome and the Abbey's directors had recently caused some resentment within the company by dedicating the profits of a US tour to another cultural project, masterminded by Lady Gregory's nephew Hugh Lane. He had for several years been campaigning to establish a gallery of modern art in Dublin, showcasing the collection of French paintings which he had built up; his mission to educate the Irish public raised some hackles, and was easily satirised, but was warmly supported by a varied range of prominent people including Yeats, the painter William Orpen, George Russell (Æ) and the labour leader Jim Larkin. The novelist George Moore believed that exposure to Manet's paintings would be a step towards the liberation of the sexually repressed Irish, relieving them from a visual diet based on 'the meagre thighs of dying saints'.[4] The members of Dublin Corporation were less enthusiastic, especially when Lane decreed that his gallery should take the form of a controversial building spanning the Liffey. The energy and passion devoted to this issue monopolised Dublin's attention in 1912/13; Yeats's feelings at what he saw as the victory of small-minded Philistines were reflected in polemical poems planted out in the *Irish Times*. Cultural self-assertion in these years was not the monopoly of Sinn Féin; in some ways it was a concomitant of the renewed surge of expectation of Home Rule.

Nevertheless, there was another aspect to the cultural atmosphere of Ireland as Home Rule loomed above the horizon in 1912: the more radical world of what Yeats called 'the cellars and garrets'. To some people, notably Constance and Casimir Markiewicz, the Abbey Theatre's productions had sold out on 'advanced nationalism', the political goal of Home Rule was far too limited, and parliamentary politicians were blind to Dublin's social problems. Though born to an Ascendancy 'Big House' in Sligo, by 1912 Constance had become a socialist, a revolutionary, and the commander of a band of militarised boy scouts, the Fianna; she and her Polish husband also started up a series of agit-prop theatre initiatives and, along with Maud Gonne, were celebrated figures in Dublin's radical-nationalist Bohemia. There was an active radical press, scathingly critical of the nationalist political establishment,

3 Quoted in C. Murray, *Twentieth-century Irish Drama: Mirror up to a Nation* (Manchester, 1997), p. 3.
4 George Moore, *Reminiscences of the Impressionist Painters* (Dublin, 1906), pp. 47–8.

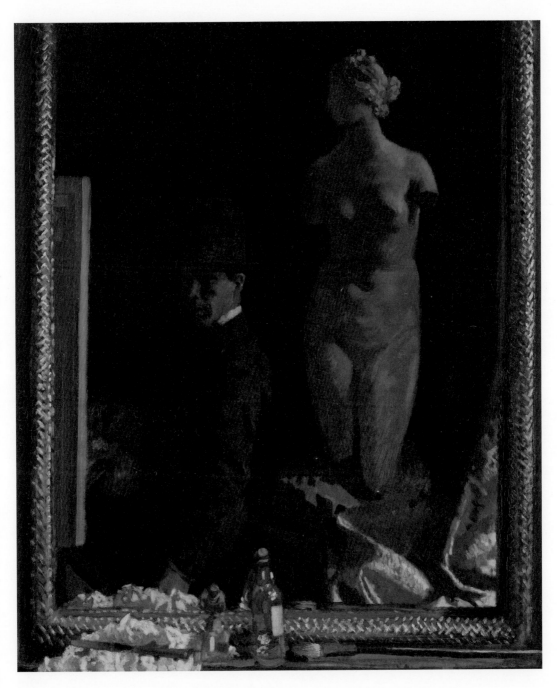

Sir William Orpen
Portrait of the Artist, c. 1906

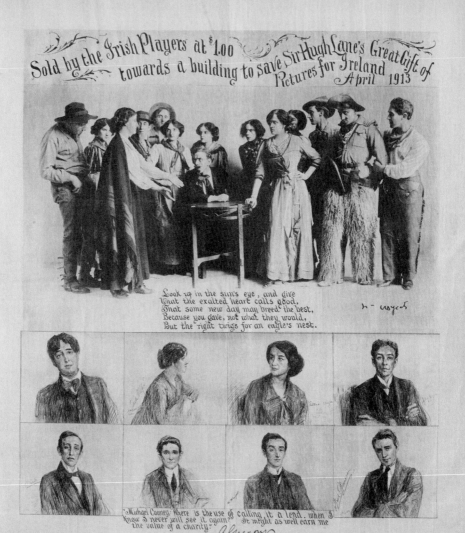

Handkerchief sold by The Abbey Players on their American Tour to Raise Funds for a Building for The Gallery of Modern Art, 1913
The upper image shows a scene from George Bernard Shaw's *The Shewing-up of Blanco Posnet*. The eight portraits at the bottom are taken from pencil sketches by John Butler Yeats done for John Quinn, in 1911–12.
Top row, left to right: Arthur Sinclair, Sara Allgood, Eithne Magee, Sydney J. Morgan.
Bottom row, left to right: J. A. O'Rourke, J. M. Kerrigan, Udolphus Wright, Fred Donovan.

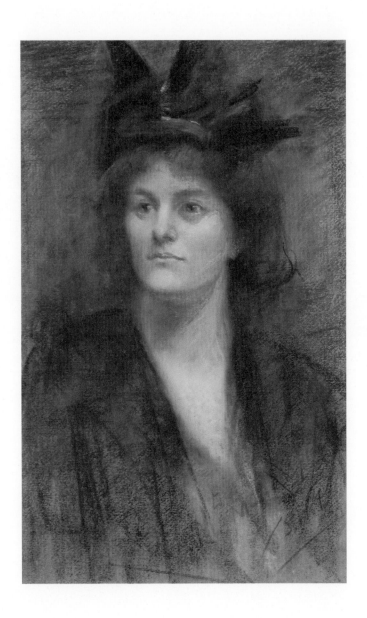

Sarah Purser
Miss Maud Gonne, 1898

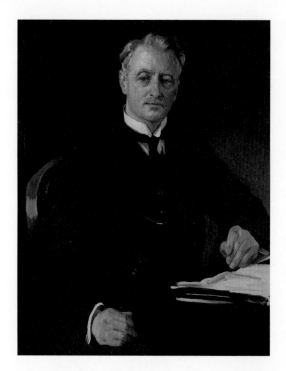 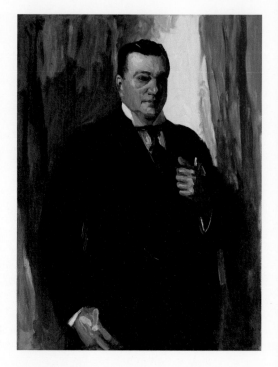

Sir John Lavery
William Cosgrave, 1923

Sir John Lavery
Joseph Devlin, MP 1871–1934, 1928

targeting the northern nationalist leader of the Ancient Order of Hibernians Joe Devlin no less than the imperially-minded Redmond. The cartoonist Grace Gifford Plunkett is an emblematic figure; like Seán Keating a pupil of William Orpen's, she and her three sisters repudiated their respectable Unionist background in Rathmines and threw themselves into Dublin's radical underworld. Against the general expectation of Home Rule, there were circles (notably around Patrick Pearse's experimental school St Enda's) which nurtured different kind of expectations, and lived in their own hectic, energetic worlds. The Ireland of 1912 was a weave of complex allegiances, febrile energies and apparently open futures. This is reflected in Hugh Lane's wish to see the prominent cultural and political figures of the day preserved in portraits by brilliant Irish painters such as John Butler Yeats, Lavery and Orpen (notably the latter's brooding portrait of Michael Davitt, a one-time Fenian prisoner who became a radical land reformer and socialist). These three notable painters are also emblematic of lives lived between England, which provided professional opportunities and artistic stimulation, and Ireland, which offered emotional inspiration and sustenance. The same was true for many of the Home Rule generation.

A quarter-century after the excitements of 1912, the aged W.B. Yeats visited this gallery, which had been recently established in what was now the capital city of an autonomous twenty-six-county Free State. His poem 'The Municipal Gallery Revisited' records how the pictures there evoked Hugh Lane's vision, the early days of the Abbey, his friends and fellow-workers Lady Gregory and John Synge and the maelstrom of politics and revolution which had intervened. 'Ireland's history', as he put it, could be 'traced in the lineaments' of the portraits hanging on the walls. The faces, scenes and images that comprise *Revolutionary States* similarly summon up a vanished world, caught at a moment before everything changed.

The futures of the people represented here are emblematic in their own way. Hugh Lane was to be drowned when the Lusitania was torpedoed by a German U-boat off the Cork coast in 1915; his dream of a permanent modern art gallery for Dublin was still unrealised, and British law refused to recognise the codicil to his will which left his landmark collection of Impressionist paintings to found such a gallery. John Redmond would die in 1918, amid the wreckage of his once-great Irish Parliamentary Party, as Sinn Féin swept the board in the post-war election. Constance Markiewicz and Patrick Tuohy would fight in the 1916 Rising; after imprisonment she would

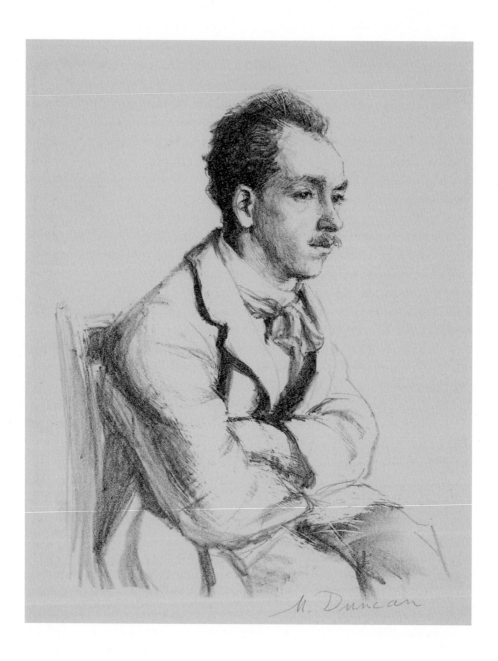

Mary Duncan
James Stephens, c. 1915

William Rothenstein
Captain Stephen Gwynn, MP, 1917

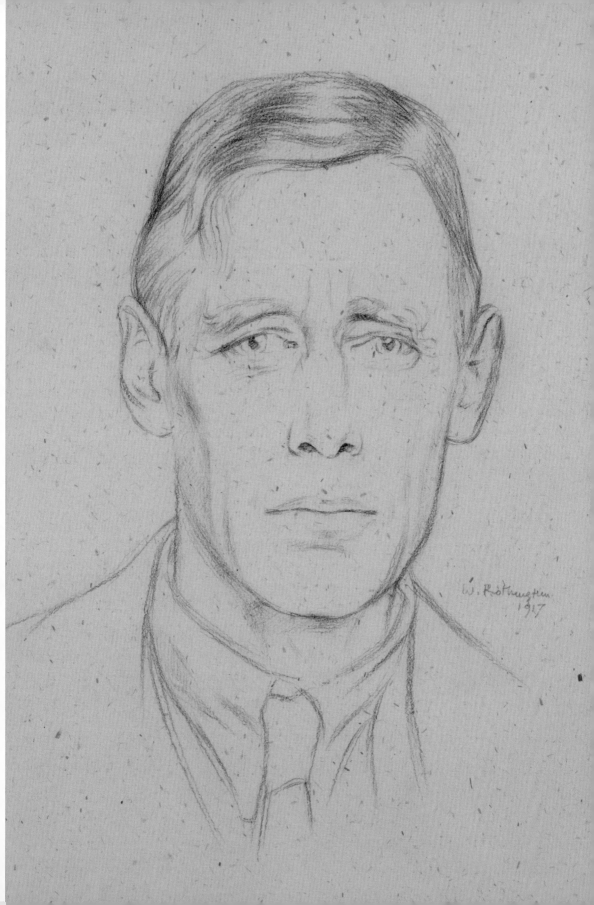

return to a heroic reception in Dublin and play a leading part in revolutionary politics, opposing the Treaty which paved the way for two new Irish states in 1921. Arthur Griffith would eventually emerge, improbably, as the first president of Dáil Éireann, the parliament of the new Irish Free State, and the old parliamentarian Timothy Healy would be its Governor-General. Douglas Hyde, founder of the Gaelic League, would become President of Ireland in 1938, under the new constitution brought in by the ex-revolutionary Eamon de Valera the year before. William Craig, one of the leaders of Ulster Unionist resistance in 1912, would – as the portrait here reveals – become Viscount Craigavon and the first Prime Minister of the new dominion of Northern Ireland.

 None of this was foreseeable in 1912, when a different future apparently beckoned for all these people. But what was evident was the energy, imagination, diversity of talent and powerful sense of history in the making represented by those active in the politics and cultural initiatives of the day. The writer and Home Rule politician Stephen Gwynn spoke for many when he wrote, rather elegiacally, in 1918: 'The Ireland of yesterday was Ireland before the revolution. We may well envy those who lived more easily and quietly in the Ireland of yesterday, and held with unquestioning spirit to the state of things in which they were born'.[5] But this may underestimate the extent to which Irish people living in the Home Rule moment expected, welcomed and worked for change – and believed, in 1912, that they were seeing it happen around them, as they campaigned for a modern art gallery, a national theatre, a more inclusive, pluralist, secular and socially conscious civic culture, and a realistic relationship with the Protestant and unionist traditions of the island. Many of the seismic upheavals which came in the ensuing decade of war and revolution were unanticipated. But in other ways, some of the ambitions, vision and expectations of the Home Rule generation eventually came to pass, in devious or roundabout ways. A century later the 'lineaments' of these avatars can, as Yeats put it, be traced in the works now hanging in the 'hallowed place' that is Hugh Lane's gallery.

Sir John Lavery
Rt. Hon. The Viscount Craigavon 1871–1940,
First Prime Minister of Northern Ireland, 1923
(detail)

5 An essay reprinted in *Irish Books and Irish People* (Dublin, 1919), pp. 105–6.

Portraits of National Interest

Logan Sisley

A distinct element within Hugh Lane's original vision for Dublin's Gallery of Modern Art was a collection of portraits of contemporary Irish men and women, which now forms the basis of *Revolutionary States: Home Rule and Modern Ireland*. Lane actively commissioned artists and pursued sitters. The series of paintings was begun by John Butler Yeats and continued by William Orpen. The processes by which these and other portraits came about and entered a public collection shed light on the creation of the historical record, its strengths and omissions.

Lane presented portraits of Sir Horace Plunkett, Edward Dowden, W.B. Yeats, W.G. Fay and J.M. Synge by Yeats, who remarked that the Synge portrait was a good bargain at £10. Lane sought to include a portrait of John Redmond, and though the Irish Parliamentary Party leader did sit for Yeats in 1903, the painting was never completed. When Lane asked Redmond to sit for Orpen in 1907, the politician replied that it was quite impossible at the time and that he was sorry that Mr Yeats had not been more successful. It wasn't until 1916, after Lane's death, that a portrait of Redmond, by John Lavery, would enter the collection.

Lane also presented portraits of Sir Antony MacDonnell, Under-Secretary for Ireland from 1902 to 1908, by both Yeats and Orpen. Yeats wrote to Lane, updating him on the progress of the sittings, boasting that MacDonnell thought his portrait 'marvellous, truly marvellous.'[1] However, the artist and sitter differed over how MacDonnell should be presented. Yeats wrote:'This is a man who knows his own mind. He appeared with all his medals on… – he wants his medals to appear.'[2] It is in Orpen's

Sir William Orpen
Lord MacDonnell, GCSI, 1904
(detail)

1 John Butler Yeats to Hugh Lane, 30 December 1903, National Library of Ireland [NLI], Ms 27,739.
2 *ibid.*

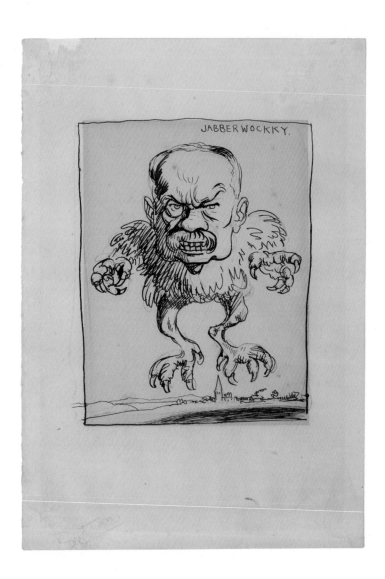

Sir William Orpen
Jabberwockky, c. 1905

John Butler Yeats
Lord MacDonnell, GCSI, 1904
Oil on canvas, 75 × 62.8 cm

Lane Gift, 1912

portrait and not that by Yeats that MacDonnell appears in full regalia with all his medals on display; only the Orpen was hung at the opening of the Gallery in 1908.

These commissions were important for Yeats who had turned to a career in art relatively late in life. Yeats complained to Lane: 'I have always believed that there are plenty of portraits to be got in Dublin. If only you could get people to believe that you could paint the portrait that they wanted. There is a little too much of God's hammer about Orpen's work. Yet because of his vigour and power of painting they give him work even with his high prices.'[3]

Orpen was paid £10 – the same as Yeats – for the portraits, which included T.W. Russell, William O'Brien, Michael Davitt, Nathaniel Hone, Rev J.P. Mahaffy and Captain Shawe-Taylor. Orpen had to chase Lane for the money, writing to his patron: 'Thank you for the card and also the nice things about the Shaw Taylor but where is the £10!!! Where is the £10!!!!... Is it lost!!! Where is the £100!! Where is the £!!!! I wake up asking myself this!'[4] In the same letter Orpen joked: 'How's Sinn Fein? Are you a grand master yet' – a reference to the spectrum of relationships that Lane had to negotiate in order to establish a broad base of support for the Gallery. W.B. Yeats wrote to Lady Gregory of the difficulties in attempting to appeal to various sections of society:

> I went to see Hugh Lane to-day and asked him if I should reply to a stupid little paragraph about him. I am not to do so, however, as he finds association with us Nationalists too injurious with the monied people. Many of his rich friends are saying that they will not help him now, that he is a part of the Movement. It's only the Gaelic League over again, etc., etc., and they had thought it something quite different.[5]

Gregory described the Gallery as a space that was 'wide and liberal for all.'[6] At the opening of the Gallery of Modern Art in 1908 in its temporary Harcourt Street premises the *Irish Times* editorial commented that 'this gathering of peers, professors, Sinn Feiners, and Gaelic Leaguers felt the true inspiration of citizenship, and forgot their daily differences.' It predicted that the Gallery might become 'a temple of peace' as well as a temple of art – 'a permanent reminder to the people of Dublin that, whatever their political differences, they are all united in the citizenship of no mean city.'[7] The idea of art as something universal that transcends politics is a recurring theme in

3 John Butler Yeats to Hugh Lane, NLI, Ms 35,823/5/14.
4 William Orpen to Hugh Lane, NLI, Ms 27,751 (1).
5 W.B. Yeats quoted in Lady Gregory, *Hugh Lane: His Life and Achievement* (London, 1921), p.61.
6 Lady Gregory, *Hugh Lane*, p.77.
7 *Irish Times*, 21 January 1908, p.6.

Sir William Orpen
Rev. J.P. Mahaffy, DD, CVD, etc., 1905

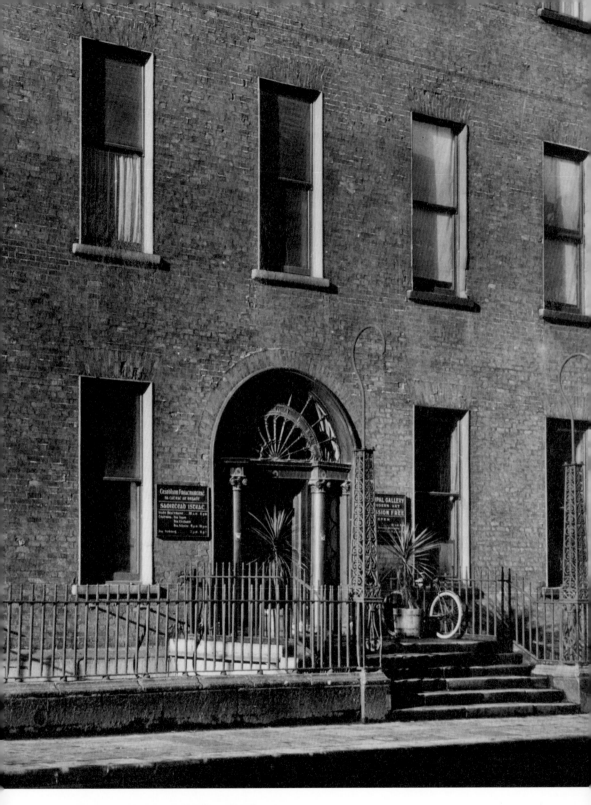

Entrance to The Municipal Gallery of Modern Art,
Clonmell House, Harcourt Street, Dublin

contemporary accounts of the founding of the Gallery. In 1906 Lord Mayo noted that art was a subject which supporters 'could all discuss on a common platform, irrespective of the cross-currents and diverse opinions that existed on other subjects.'[8] A few years later, that common ground would become harder to sustain.

An Claidheamh Soluis, the Gaelic League newspaper, aligned the Gallery with nationalist ambitions. It proclaimed that Lane and the Gaelic League were allies and reaffirmed Lane's narrative of Irish art emerging again out of the shadow of foreign influence: 'The artist had his place, and a noble place it was, in Irish Ireland; in vulgar, squalid, out-at-elbows Anglo-Ireland there has been no room for him.' It saw the Gallery as 'a manifestation of the new life which is commencing to surge through the veins of Ireland.'[9] As an advocate for the Irish language, the League celebrated the Irish inscriptions over each door within the Gallery. The invitations to the opening had also been bi-lingual, of which Thomas Bodkin wrote: 'It was typical of Lane that the cards were printed in Gaelic and English… for he sought quite sincerely to conciliate every kind of opinion that might be used to further his work.'[10] In the changed political climate after 1916, Irish signage was seen to be a liability as much as an asset. Hanna Sheehy Skeffington recalled: 'I remember during the 'Tan period how our Libraries Committee had to take down the sign in Irish outside the Gallery lest it attract undue attention and get the building sacked.'[11]

Biographical notes on the subjects were prepared for the Gallery's first catalogue by Sarah Cecilia Harrison and she wrote of those who had been imprisoned in the same matter-of-fact way that she recorded eminent members of the establishment, perhaps revealing her own political inclinations. Of Orpen's portrait of William O'Brien she stated: 'Member for Cork City. Four times in prison for political offences. Author of "Recollections". Founder of the United Irish League.' O'Brien described himself as 'one of the most impatient of sitters' but was flattered by Lane's suggestion 'that a portrait of myself could be a matter of national interest.'[12] On a lighter note, George Moore discussed the portraits of O'Brien and Russell exhibited in 1906 with a correspondent from the *Weekly Irish Times*, arguing that it was not necessary to know a sitter to judge whether or not a painting was a good likeness: 'Mr O'Brien's head is, perhaps, more interesting than Mr Russell's, so far as painting is concerned. Russell's gesture is good – his shoulders and arms; in fact there is a great deal of the North about it. But he seems a little proud of his resoluteness.'[13]

8 *Irish Times*, 10 February 1906, p. 8.
9 'The future of Irish art', *An Claidheamh Soluis*, 25 January 1908, p. 9.
10 Thomas Bodkin, *Hugh Lane and his Pictures* (Dublin, 1956), p. 19.
11 Hanna Sheehy Skeffington, 'Sarah Harrison and Her Work', *Irish Press*, 5 August 1941.
12 William O'Brien to Hugh Lane, 31 March 1905, NLI, Ms 27,755.
13 'Mr. George Moore on Art', *Weekly Irish Times*, 31 March 1906, p. 13.

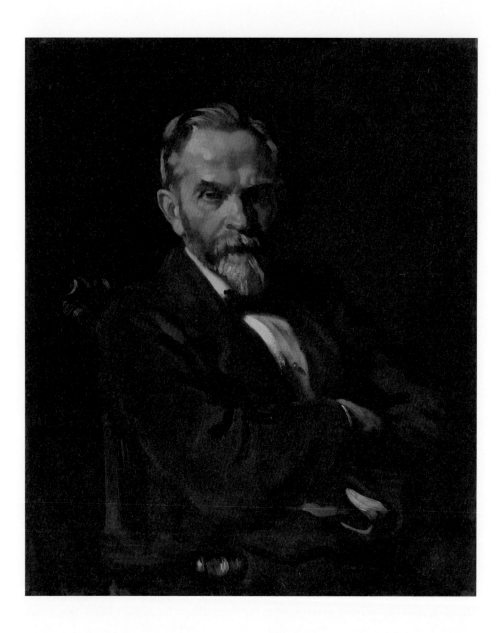

Sir William Orpen
The Right Honourable Sir Thomas
W. Russell, Bart., 1905

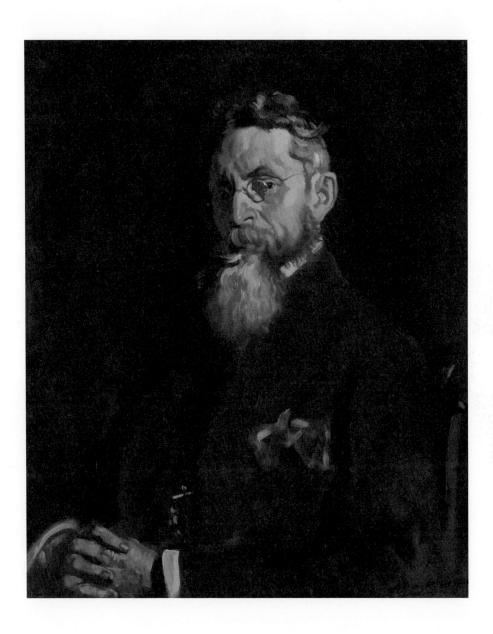

Sir William Orpen
William O'Brien, MP, 1905

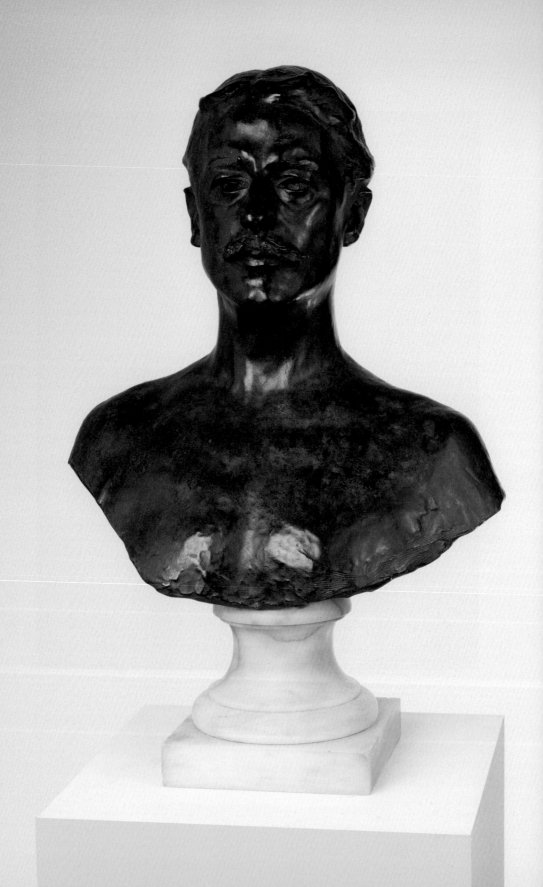

John Butler Yeats had tried unsuccessfully for sittings with George Wyndham, but he was to be represented in the collection by a bust by François-Auguste-René Rodin. Wyndham, Chief Secretary for Ireland up to 1905 and remembered for the Land Act of 1903, wrote to Rodin of Lane's rapture at seeing the plaster version of the bust when it arrived in Dublin. He had also raised with the sculptor the possibility of Lane acquiring *The Age of Bronze* for the Gallery, but warned that Ireland was not a rich nation. He hoped, however, that Dublin would establish a gallery that lovers of art and of Ireland would cherish and that Rodin's masterpieces would awaken a nation sleeping in pain but disposed towards life and art.[14] Lane successfully negotiated the purchase of *The Age of Bronze* for £200 and the Wyndham bust was presented by Rodin himself.

Wyndham's bust was shown in the sculpture room along with Oliver Sheppard's portrait of John O'Leary. The artist donated a plaster bust of the Fenian leader which was later cast in bronze. It was shown at the Royal Hibernian Academy in 1904, when Edward Martyn declared the bust to be 'a symbol of sincerity and self-centred indifference to the petty interests which tempt average men to betray principle.'[15] In the same article in *An Claidheamh Soluis*, Martyn aligned foreign art with moral decline: 'There is, of course, a preponderance of cosmopolitanism with its attendant vices of vulgarity and ineptitude… it is not too much to hope that a vigorous and distinctive national art may grow out of so inspiring a subject as Religion.' It was such views that were satirised by Grace Gifford Plunkett in her drawing *Edward Martyn Having a Week of it in Paris*.

The O'Leary portrait was also shown at the International Exhibition in Herbert Park in 1907 and Sheppard was one of a number of artists on the organising committee for the Irish Art Section. Partly in response to the proposal to create the International Exhibition, the Gaelic League had in 1905 begun organising national exhibitions of art and industry in conjunction with its annual *Oireachtas* events. The League believed that the Exhibition's promotion of foreign imports would displace Irish-made goods. It was at the 1907 *Oireachtas* Art Exhibition at the Royal Hibernian Academy that the Dublin-born American Augustus Saint-Gaudens revealed to Irish audiences the statue for his monument to nineteenth century nationalist leader Charles Stewart Parnell.

A committee had been formed in 1898 to erect a national monument to the former Home Rule leader and in 1903 a contract was signed with the academic sculptor

François-Auguste-René Rodin
The Right Hon. George Wyndham, MP, 1904

14 George Wyndham to Auguste Rodin, 25 December 1904, in Guy Wyndham (compiler), *Letters of George Wyndham*, vol. II (Edinburgh, 1915), p. 520.

15 Edward Martyn, 'Irish Ireland at the Hibernian Academy,' *An Claidheamh Soluis*, 9 April 1904, p. 8.

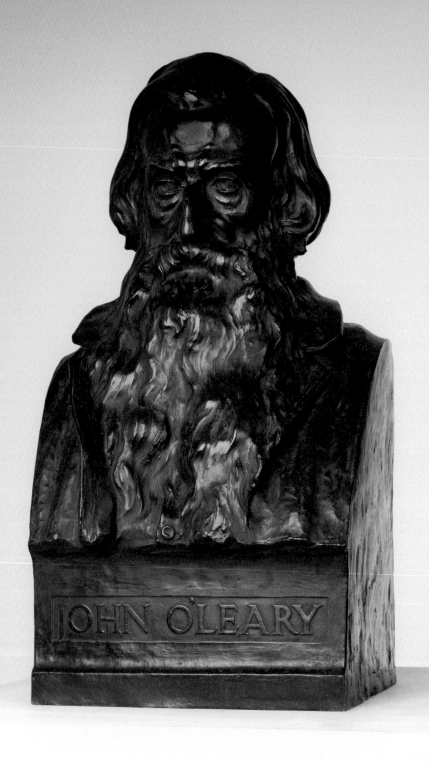

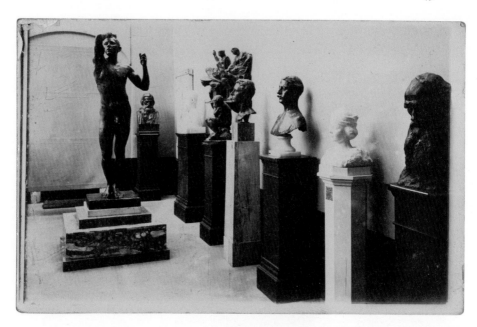

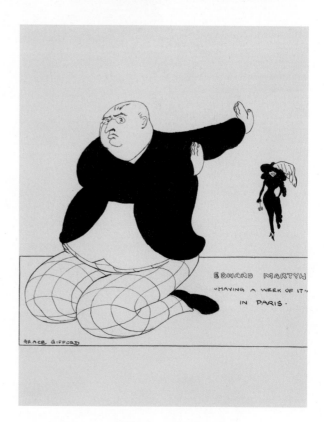

Oliver Sheppard
Portrait Bust of John O'Leary, 1903

Sculpture Gallery in The Municipal
Gallery of Modern Art, Clonmell
House, Harcourt Street, Dublin

Grace Gifford Plunkett
*Edward Martyn Having a Week of
it in Paris*, n.d.

Saint-Gaudens, who was visited by John Redmond at his studio in New Hampshire the following year. *The Irish Architect* reported that the artist 'laboured with keen zest and enthusiasm begotten of his Celtic origins.'[16] The completed monument was unveiled by Redmond near the Rotunda Hospital, Dublin, on 1 October 1911. The symbolism of the event was articulated by *The Freeman's Journal*:

> The unveiling of the Parnell monument would of itself be a memorable event, certain to attract worldwide interest. All the circumstances surrounding the event have, however, tended to emphasise its interest and importance. The political outlook is eminently favourable to the Irish cause. Never in the history of the constitutional movement has the atmosphere been clearer and brighter.[17]

In creating a retrospective portrait, the process was very different to that enjoyed – or endured – by Yeats or Orpen. Saint-Gaudens worked from numerous photographs and even had a suit made from the original pattern by Parnell's former Dublin tailor.

In the following years of uprising and war, photography would come to play an important role in memorialising those whose lives were cut short. Sarah Cecilia Harrison based her portrait of the pacifist, nationalist and suffragist Francis Sheehy Skeffington on the photograph that was published, after he was killed in 1916, on the cover of *The Irish Citizen* – the newspaper he had founded with Hanna Sheehy Skeffington. Their friend Thomas Kettle, Irish Party MP and first Professor of Economics at the National University of Ireland, was recorded in paint by Seán O'Sullivan, based on the frontispiece photograph in Kettle's *The Ways of War*. He died in 1916 at the Battle of the Somme, having followed Redmond's controversial call to fight alongside the British army.

While the opening of the Gallery of Modern Art had been a significant achievement, its future was hardly assured. The Gallery had been placed under the management of a sub-committee of Dublin Corporation's Libraries Committee. Gallery funding was uncertain and city libraries were even closed briefly to keep the Gallery open. During the Gallery's financially precarious first year Alderman W.F. Cotton had guaranteed to pay the rent until the funding situation was remedied. Dermod O'Brien painted Cotton in 1910 and the artist wrote to Lane of how the hanging arrangements would accommodate the new portrait:

Augustus Saint-Gaudens
Model for Parnell Monument, c. 1905
Shown inside the artist's studio, Cornish,
New Hampshire.

16 'The Parnell Monument', *Irish Architect and Craftsman*, 30 September 1911, p. 495.
17 *The Freeman's Journal*, 2 October 1911, p. 5.

Dermod O'Brien
Alderman W.F. Cotton, MP, 1910

Sir William Orpen
The Right Honourable Augustine Birrell, MP, 1907

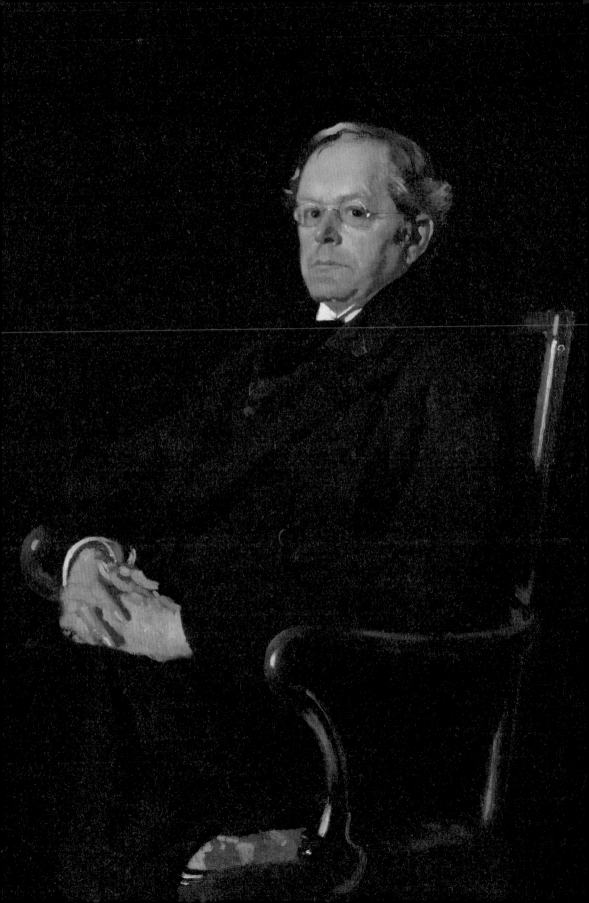

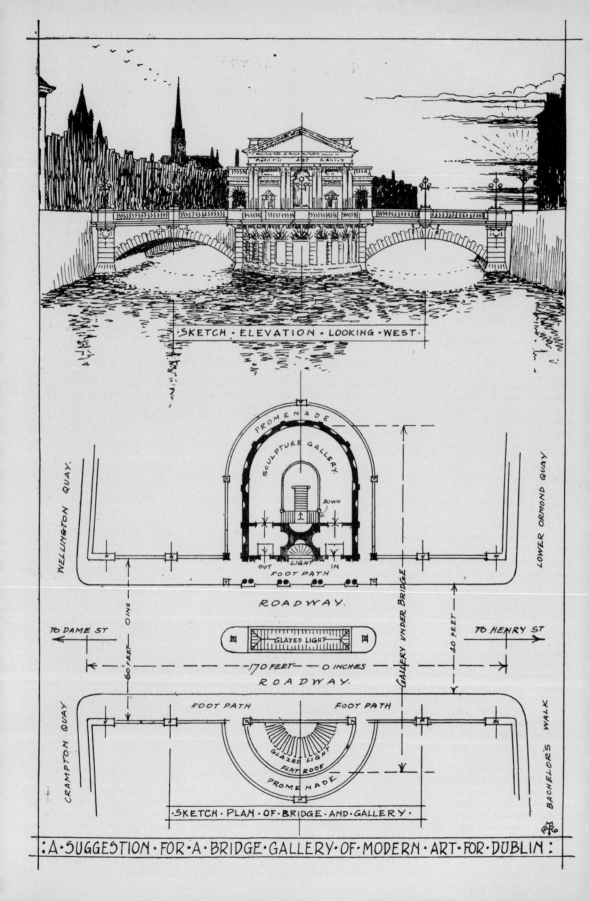

SKETCH·ELEVATION·LOOKING·WEST.

DUBLIN·ART·GALLERY

PROMENADE

SCULPTURE GALLERY

DOWN

OUT LIGHT IN
FOOT PATH

ROADWAY.

WELLINGTON·QUAY.

LOWER ORMOND QUAY

GALLERY UNDER BRIDGE

TO DAME ST

GLAZED LIGHT

170 FEET — 0 INCHES

ROADWAY.

TO HENRY ST

60 FEET 0 INS

40 FEET

CRAMPTON QUAY.

FOOT PATH FOOT PATH

GLAZED LIGHT

FLAT ROOF

PROMENADE

BACHELOR'S WALK

SKETCH·PLAN·OF·BRIDGE·AND·GALLERY.

:·A·SUGGESTION·FOR·A·BRIDGE·GALLERY·OF·MODERN·ART·FOR·DUBLIN·:

I am putting MacDonnell above Ly Gregory with Sir H.P. one side & T.W.R. the other side of him. Ly Gregory is flanked by O'Brien & Davitt & below him George Russell which I have removed to make room for Birrell on the other side where he is in an excellent light with Orpen's self next & beyond that Miss Barlow. I have moved Shawe Taylor to Miss Barlow's place, Mahaffy next to his place & Hone to take his place. This gives a little more space & gets the canvas (I forget what) out of the shadow. Cotton I will put beside O'Brien where Davitt was, moving them all 6 inches out of the shadow.[18]

Legislation was required to enable the Gallery to be vested in the Corporation and for the latter to raise the libraries rate to fund the Gallery. This was being held up in Westminster by unionists as a blocking strategy. One of the Gallery's keenest supporters, the Sinn Féin Alderman Thomas Kelly, recalled how Sarah Cecilia Harrison lobbied politicians to see the legislation through: 'She left no party or group or individual who had any influence without letting them know of the position brought about through personal spleen or political bias.'[19] Redmond wrote to her in April 1911 that he would do everything in his power to ensure this Bill's passage into law and Augustine Birrell, Chief Secretary for Ireland from 1907 to 1916, urged Harrison not to abandon hope. The matters were finally resolved in 1911 although the question of a permanent site for the Gallery would remain contentious.

Numerous sites had been proposed but by 1913 Lane had settled on an architect – Edwin Lutyens – and a site – the Ha'penny Bridge over the river Liffey. Lady Gregory related that Lane was looking ahead to Home Rule and envisaged 'a new Parliament House with a river front, the rebuilding of all that was poor and ugly, all Dublin put in harmony with what it already possessed of beauty.'[20] Aside from the questions of money and logistics, which were strenuously debated, the nationality of the architect became a factor. Even before Lutyens's plans were publicly revealed, *The Irish Architect* expressed the hope that 'architects and others interested in the encouragement of native effort will refrain from giving any financial support to this project until the Committee publicly declare that it is not their intention to boycott the architectural profession in Ireland.'[21] Horace O'Rourke (who would later design the extension to the Gallery's eventual home on Parnell Square) even published his own proposal for a bridge gallery. The story of Dublin Corporation's failure to back

Horace T. O'Rourke
'A Suggestion for a Bridge Gallery of Modern Art for Dublin', *Irish Architect and Craftsman*, 30 August 1913, p. 383

18 Dermod O'Brien to Hugh Lane, 22 August 1910, NLI, Ms 35,823/6.
19 Thomas Kelly, 'Pallace Row', *Dublin Historical Record*, vol. IV, no. 1 (September–November 1941), p. 11.
20 Lady Gregory, *Hugh Lane*, p. 111.
21 *The Irish Architect and Building Trades Journal*, 18 January 1912, p. 1292.

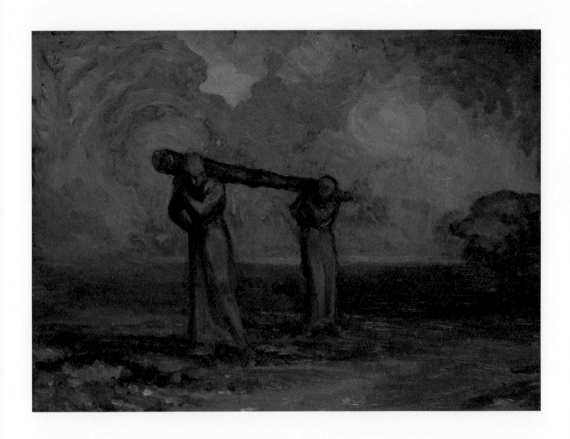

George William Russell (Æ)
The Log Carriers, c. 1904

Dermod O'Brien
Sheepshearing, c. 1901

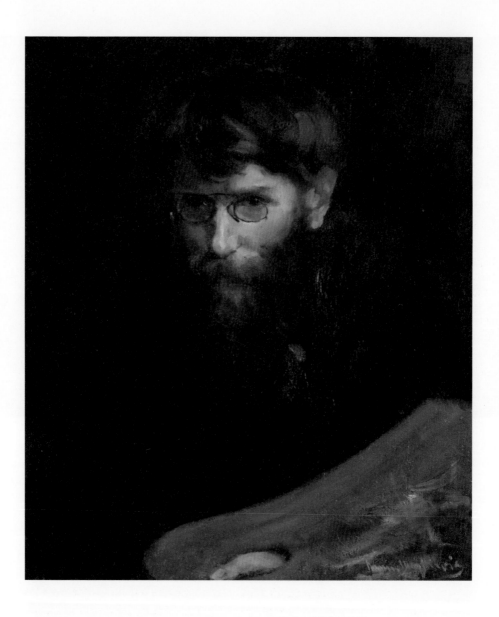

Count Casimir Joseph Dunin de Markievicz
George Russell (Æ), 1904

Lane's scheme and the withdrawal of his conditional gift of thirty-nine continental paintings is well documented. In September 1913 Dublin was embattled by the fatal collapse of tenement houses in Dublin and by the lock-out; the political climate had clearly changed from 1904 when Lane first exhibited at the Royal Hibernian Academy the pictures that would form the nucleus of the Gallery of Modern Art. On a visit to America in 1914 – when the thirty-nine continental paintings had been removed on loan to Belfast – Lane still optimistically expressed the hope that the coming of Home Rule would see a resolution of the conflict over the bridge. It was reported that 'he has been agitating to secure a permanent building and hopes that when Home Rule comes he will get one. He thinks municipalities rather slow to appreciate the educational value of fine paintings.'[22]

Despite the setbacks to the Gallery, Lane continued to promote the revival of an Irish school of painting. Lane – along with Sarah Purser and Dermod O'Brien – was on the organising committee of the Whitechapel Art Gallery's *Irish Art* in London from May to June 1913. Loans to that exhibition from the Gallery of Modern Art included Yeats's portraits of Standish O'Grady and J.M. Synge, Mancini's portrait of Lady Gregory, Count Markievicz's portrait of George Russell (Æ), a self-portrait by Harrison and Max Beerbohm's *Mr W.B. Yeats Presenting Mr George Moore to the Queen of the Fairies*. The timing of the exhibition – in the midst of the Third Home Rule Bill's protracted passage through the Houses of Parliament – was noted by *The Derby Telegraph*:

> The exhibition is particularly timely in view of Ireland's impending realisation of her Nationalist aspirations. No one who visits Dublin, Cork, or any one of the other great cities of Ireland can fail to be infected in some measure by their dominant nationalism, and it is with something of the same feeling that one comes away from the collection of pictures and national relics which have been brought together at the Whitechapel Gallery.[23]

When soliciting works for the exhibition, P.H. Miller, secretary of the Allied Irish Artists in London, tried to contact John Lavery but found him 'actually shut up with his Royal picture.'[24] Lavery had been commissioned by the publisher W.H. Spottiswoode to paint King George V and family, the study for which he gave to the Belfast Museum and Art Gallery. This gesture was made in 1916 after he presented a triptych featuring

22 *American Art News*, vol. 12, no. 15 (17 January 1914), p.1.
23 'Irish Art in Whitechapel,' *The Derby Telegraph*, 21 May 1913.
24 P.H. Miller to Gilbert Ramsay, 18 April 1913, Whitechapel Gallery Archive, London.

Hazel Lavery as the Madonna to St Patrick's Church in Belfast, because he wanted 'to show the other side that I was not a bigot'. Later that year he invited Edward Carson and John Redmond to sit for portraits on the condition that they would be presented to the Dublin Gallery to be hung side by side. Lavery claimed that each thought the other's portrait was the better:

> Carson, knowing that I was a Catholic, although from Belfast, looking at the two portraits together, remarked, 'Ah, it's easy to see which side you're on.' Redmond did not criticise, he only said plaintively, 'I have always had an idea that Carson and I might some day be hanged side by side in Dublin, and now it has come to pass.' When the Free State had been established I painted a second portrait of Carson, for Belfast. He looked at it for a long time and, as if speaking to himself, said, 'Well now, you can call that "Edward Carson after the Surrender"'.[25]

Awakened to historical developments around him, and perceiving the studio as 'neutral ground', Lavery would go on to paint the signatories to the 1922 Anglo-Irish Treaty and the various 'contending elements' of his native city, Belfast. There are parallels in this project and in Lane's earlier conciliatory ethos in acquiring portraits from Yeats, Orpen and others. Lavery donated the Redmond / Carson portraits to a charity sale and Ellen Duncan, the first permanent curator of the Gallery of Modern Art, sought out a buyer. She found one in Colonel Hutchinson Pöe, who wrote to Duncan:

> Although, personally speaking, I cannot say I admire the Carson portrait, & feel it savours too much of a 'caricature,' I suppose he & his friends are satisfied with it, or they would hardly have acquiesced in Lavery giving to the Red X.
> I am afraid that, in existing circumstances, & with such acute divisions in the Nationalist ranks, the interest in these two portraits which, otherwise might have been looked for, will be but small, & we must only hope that in years to come, the city may be glad to have them.[26]

As Pöe notes, the position of Redmond was compromised following his backing of enlistment during the war, the Easter Rising and the rise of Sinn Féin. Indeed, both leaders were in the declining years of their political careers.

25 John Lavery, *Life of a Painter* (Boston, 1940), p. 217. See also
 Sinéad McCoole, *Passion and Politics* (Dublin, 2010).
26 Colonel Hutchinson Pöe to Ellen Duncan, June 1917,
 Dublin City Gallery The Hugh Lane Archive.

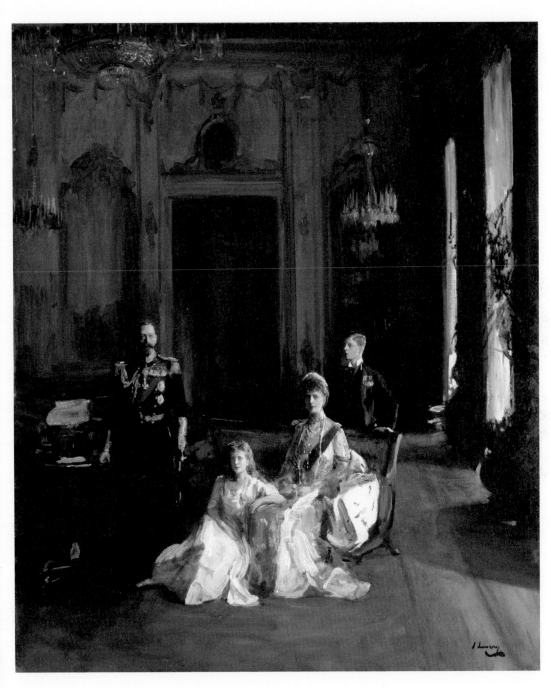

Sir John Lavery
Second Study for the King, the Queen, the Prince of
Wales, the Princess Mary, Buckingham Palace, 1913

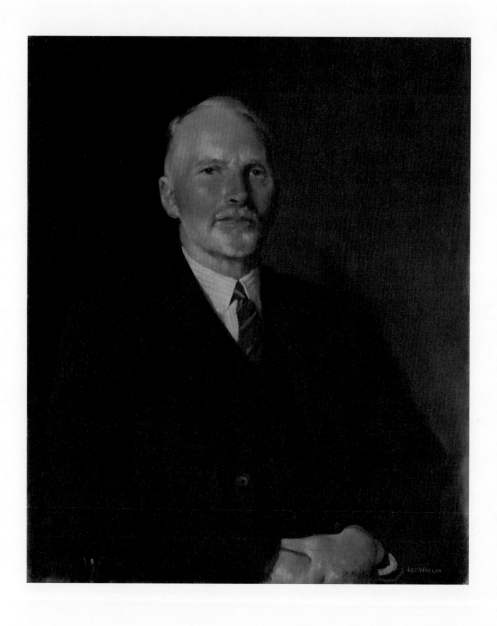

Leo Whelan
William O'Brien, c. 1946

At a lecture on portraiture in 1913 Dermod O'Brien argued that:

Many people who would not dream of buying a picture would pay to have their portraits painted, even though they may not be subjects to make what was commonly known as a pretty picture. Consequently the tendency of all modern exhibitions was to get loaded up with portraits, of which very few were in any way pictures to interest the general public.[27]

Many of those represented in *Revolutionary States: Home Rule and Modern Ireland* may have fallen from the public imagination and many other figures were inevitably excluded from the public record, despite Lane's inclusive approach. The visual record of the political elite is overwhelmingly male and the Irish peasant so often appears as a nameless hero (one exception being *My Friend Michael Mangan* from the collection of the Ulster Museum). Lane always envisaged that his portrait collection would be augmented over time and in addition to Lavery's donation of the paintings of Treaty signatories in 1935, Mina Carney's bust of Jim Larkin was presented by the Workers' Union of Ireland in 1937 and Leo Whelan's portrait of William O'Brien was presented by the Irish Transport and General Workers' Union a decade later. It is perhaps not surprising that the great foe they shared with Hugh Lane, William Martin Murphy, is not included in the collection.

Traditional portraiture would fade out of fashion as the twentieth century progressed and the very notion of a national school of art that Lane championed would seem irrelevant in the context of the radical developments in modern art in the period following the First World War. However, the works of John Butler Yeats, Orpen, Harrison, Rodin and others collected by Lane and his supporters in the first decades of the twentieth century remain a valuable record of the political and cultural circles in Ireland when the nation was on the cusp of momentous change.

27 'Lecture on Portrait Painting', *Irish Times*, 11 March 1913, p. 5.

1912 and all that

Michael Laffan

In the spring of 1912 Irish nationalists could say to one another 'this time it will be different; this time, at long last, we will achieve our objective'.

The demand for Home Rule, for the creation of a subordinate parliament and government in Dublin, had dominated Irish politics since the 1870s. This struggle had been marked by numerous disappointments. The British Prime Minister William Gladstone was converted to the idea of a devolved government in Ireland, but in 1886 his Home Rule Bill was defeated in the House of Commons when sections of his own Liberal party revolted against him. Seven years later the Lords rejected a second bill by a margin of ten to one.

In subsequent decades voters in a large majority of Irish constituencies returned Home Rule candidates to Westminster. Their wishes were ignored, both by hostile Conservatives and by friendly Liberals – who proved to be unreliable allies, and whose interests had moved on since Gladstone's time. During these bleak years in the wilderness some Irish nationalists feared that a series of reforms, in particular the Land Acts, would remove so many Irish grievances that they would blunt the demand for a devolved administration. Home Rule *might* be killed with kindness.

Suddenly everything changed, and for reasons that had nothing to do with Irish circumstances. The House of Lords brought down the Liberal government by rejecting its budget, and this precipitated a long struggle between the two houses of parliament. In 1911 this resulted in a decisive victory for the Commons. Two general elections in rapid succession had resulted in near-equality between the main British

Sir John Lavery
John E. Redmond, MP, 1916
(detail)

parties, thereby enabling Irish nationalists to hold the balance of power. The Liberal government ended the Lords' veto, and a large majority in the Commons favoured Home Rule. The party leader, John Redmond, seemed to have achieved the position which he and his predecessors had sought for many years. But his many critics saw him as an unscrupulous blackmailer, as a puppeteer who manipulated a weak and corrupt British government; they refused to tolerate the idea that Irish nationalist MPs' parliamentary votes were equal to those of their British counterparts.

In April 1912 the Prime Minister, H.H. Asquith, introduced a Third Home Rule Bill in the House of Commons. In many respects it was an ungenerous measure, and Irish responses to it were mixed. It envisaged a parliament with an elected lower house and a nominated senate. The Home Rule parliament could vary standard UK taxation but could not introduce any new taxes. A substantial range of responsibilities was 'reserved' to Westminster, some for a fixed period and some indefinitely. These included not merely defence and foreign affairs, but also the police, old age pensions, land purchase tax and the post office savings bank. There was a widespread impression that the financial arrangements were too complicated, and also a fear that the new system might end the recent pattern whereby Ireland was subsidised by British taxpayers. Home Rule might prove to be expensive. Ireland would continue to send MPs to London, but their number would be reduced from 103 to 42. (Until then Ireland was grossly over-represented in the House of Commons, and now that pattern would be reversed.) No special provision was made for the unionist minority in north-east Ulster, and Asquith rejected the demand of what he described as a relatively small minority 'to refuse to recognise the deliberate constitutional demands of the vast majority of the nation'. Crucially, the Imperial parliament could 'at any time nullify, amend or alter any Act of the Irish Parliament'.[1]

Redmond welcomed the Bill, and there were torchlight processions in several towns. The *Connacht Tribune* described it as 'the charter of Irish liberty'. But such elation was accompanied by prudence and caution. The measure was generally approved, either as a final settlement of Ireland's claims (this was Redmond's view) or as a modest beginning, a 'stepping stone' to a fuller degree of independence. Even some nationalists who would later take a more radical stance gave the Bill a cautious endorsement; in particular, P.H. Pearse welcomed it because it would hand over control of much of the educational system to Irish nationalists.

1 *Hansard*, House of Commons, 11 April 1912, cols. 1401, 1411.

Asquith and many of his colleagues were reluctant to devote much time and effort to Irish questions, and they would have preferred to concentrate on other problems. But some of their critics were more full-blooded, and the Bill encountered harsh criticism and outright repudiation. Irish republicans, then a tiny and unrepresentative minority, dismissed it as an utterly inadequate response to their demand for freedom. More significantly, Ulster unionists dismissed the measure, and they made it clear from the very beginning that they would do all in their power to block it. They were supported by the Conservative party, which was appalled by what it saw as a dangerously radical government and which saw Unionist Ulster's hostility to Home Rule as their enemy's weak link.

One day after Asquith's speech in the House of Commons, the Conservative leader Andrew Bonar Law and the leader of the Irish unionists, Edward Carson, addressed a large protest meeting in Belfast. Friendly observers estimated the crowd at 200,000. This gathering resolved unanimously that 'the government of Ireland by a Home Rule Parliament would infallibly lead to bitter racial and sectarian strife, to lasting injury to our commerce and industries; would involve ruin to our civil and religious liberties … and would be the first step in the disintegration of the great Empire'.[2]

This proved to be the beginning of a two-year conflict between Irish supporters and opponents of the Home Rule Bill, and by their Liberal and Conservative allies in Britain. It resulted in the radicalisation and polarisation of Irish society; the weakening and discrediting of the moderate nationalist Home Rule party; the creation of two rival paramilitary forces, each committed to rebellion against the British government if it failed to achieve its objectives; and a combination of circumstances that made possible the Easter Rising of 1916. Ultimately and ironically, the only group to implement Home Rule in Ireland was the one group that had opposed it with ferocity and passion: the Ulster unionists.

The Home Rule question also polarised British politics to a greater extent than any other issue or crisis had done since the seventeenth century; it provoked widespread fears, not merely of rebellion but of civil war; and it resulted in the British government losing effective control of its army. The Irish crisis had reached such a dangerous stage by the summer of 1914 that some months later Asquith was able to regard the outbreak of the First World War as the greatest stroke of luck in his political career.[3] He believed that it had saved him, and Britain, from an even greater disaster.

2 *Irish Times*, 13 April 1912, p. 11.
3 Roy Jenkins, *Asquith* (London, 1964), p. 335.

None of this could have been foreseen when the Third Home Rule Bill was unveiled, and when it was easy to dismiss the Ulster unionist threats as no more than windy rhetoric. For a long time to come Carson's Ulster Volunteers were dismissed as harmless and their wooden guns provoked derision. After so many years of frustration and disappointment it was perhaps understandable that Redmond, like so many other Irish nationalists, felt tempted to believe that the worst was over, and that (despite the government's ominous tendency to compromise) the promised land was in sight. But he and his party soon fell victims to a new extremism which, first in Ireland and then – on a vastly greater scale – elsewhere in Europe, swept away the stable world of 1912.

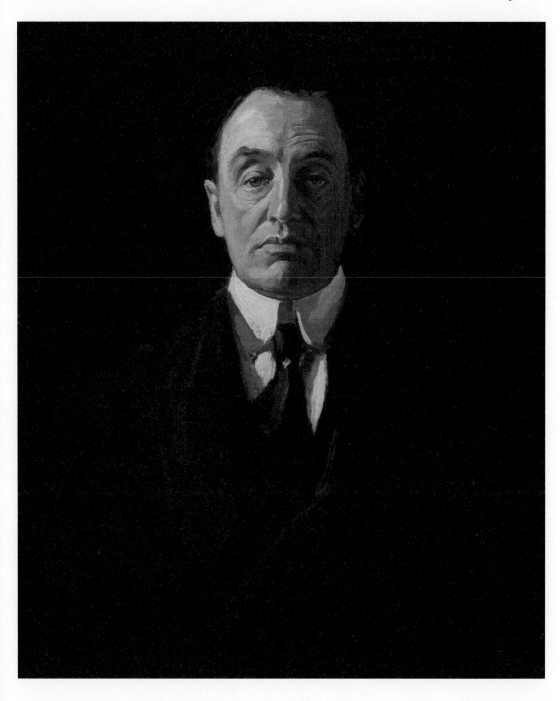

Sir John Lavery
Sir Edward Carson, MP, 1916

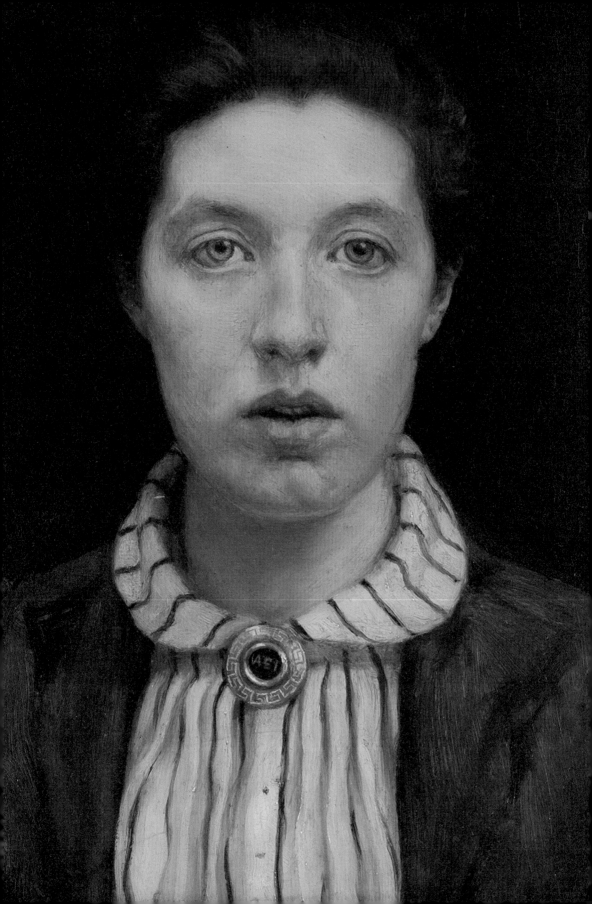

Sarah Cecilia Harrison: Artist, Social Campaigner and City Councillor

Margarita Cappock

Sarah Cecilia 'Celia' Harrison (1863–1941) came from a prosperous Northern Irish family steeped in politics so perhaps it was somewhat inevitable that from the time she arrived in Dublin in 1889 she would immerse herself in the political and social fabric of Dublin life, devoting herself wholeheartedly to many campaigns and becoming deeply involved in philanthropic, political, civic and artistic efforts. However, in tandem with these activities, Harrison established herself as a well-respected portrait painter and also became one of Hugh Lane's staunchest supporters and closest allies in the campaign for the establishment of a modern art gallery for Dublin. The fact that her commitments were not mutually exclusive indicates that she was both a progressive and enlightened individual – an entitlement to employment, adequate housing and access to modern art for all were viewed by her as compatible aspirations. What was also in Harrison's favour was that her strikingly modern and enlightened approach was married with a strong degree of tenacity and pragmatism.

Born at Holywood House, Co. Down, she was the daughter of Henry Harrison, a wealthy landowner and Justice of the Peace, and his second wife, Letitia Tennent, the daughter of R.J. Tennent (1803–80), a Liberal MP for Belfast. The family had a strong nationalist inclination and on her mother's side Celia was a great grand-niece of Henry Joy McCracken (1767–98), United Irishman,[1] and his sister Mary Ann McCracken (1770–1866), a radical and philanthropist who was also involved in the United Irish movement. Indeed, parallels can be made between Harrison and Mary Ann McCracken in that both were articulate yet trenchant nationalists and tenacious

Sarah Cecilia Harrison
Portrait of the Artist, 1900
(detail)

1 In 1926 Harrison painted Henry Joy McCracken's portrait from a miniature which is now in the Ulster Museum, Belfast.

woman who also worked tirelessly on behalf of the vulnerable in society. Harrison's brother, Henry Harrison (1867–1954), was also involved in politics, and in 1890 was elected nationalist MP for mid-Tipperary. He became Parnell's secretary and supported Parnell during the 1891 political crisis, so it is highly likely that Harrison met Parnell and other political figures.

The death of Sarah Cecilia Harrison's father in 1873 led to change and the family moved to London, where they lived at 9 Chester Place. From 1878 to 1885 Harrison attended the Slade School of Art, one of the most important English art schools of the late nineteenth and twentieth century, where she studied under Alphonse Legros, an associate of Courbet and a friend of Whistler. At the Slade she won a scholarship, various prizes and a silver medal for 'Painting from the Antique'. She also maintained her connection with Belfast and in 1879, at the age of 16, exhibited with the Ladies Sketching Club there. Harrison also furthered her artistic education with travels to Italy, Paris and Holland and in 1890 she visited Étaples in Northern France and Brittany.

In 1889 Harrison moved to Dublin and lived and worked at 16 Fitzwilliam Place and in the same year she exhibited a portrait of Francis Dwyer, Esq. at the Royal Hibernian Academy. Thus began a long association with the RHA that would last until 1933 with Harrison exhibiting over sixty works, mostly portraits. She changed residence several times during her life but by 1905 had established herself in Dublin with an address at 33 Harcourt Street. While establishing herself as an artist, she also became involved with Hugh Lane's proposal to found a new gallery of modern art in Dublin. In turn, Lane recommended Harrison as a portrait painter to close friends such as the Bodkins.

Lane's campaign for a modern art gallery for Dublin had begun in 1901 when, on a visit to Dublin from his home in London, he saw an exhibition of the work of John Butler Yeats and Nathaniel Hone, organised by fellow artist Sarah Purser. In order to promote his proposed gallery, Lane embarked on a series of exhibitions, the first of which was the 'Exhibition of a Selection of Works by Irish Painters' in the Guildhall in London in May 1904. Soon after returning from a trip to Italy in October 1904, Lane began working on his scheme for the development of art in Ireland.

The origins of this were in the collection of works owned by the Scottish entrepreneur, James Staats Forbes, who had died in April 1904 leaving a collection of 4,000 pictures. Staats Forbes admired John Constable and the Barbizon school

and his collection also included 150 works by Jean-François Millet and 160 works by Jean-Baptiste Camille Corot. The executors of Staats Forbes's estate intended putting the entire collection up for sale but they were approached by Lane, who suggested that a selection of the paintings be shown in Dublin where the aspiration was that a number of philanthropists would purchase the works and donate them to the city of Dublin. In addition to the 160 works he selected from the Staats Forbes collection, Lane also borrowed three Monets, two Manets and a Puvis de Chavannes from the art dealer Durand-Ruel in Paris. The exhibition was opened by the Lord Mayor at the Royal Hibernian Academy on 21 November 1904. A number of the pictures were offered to Dublin for £20,000 and subscriptions were sought from the public. A letter from Sarah Cecilia Harrison appear in the *Irish Times* on 12 December 1904 and reads: 'Sir, If you are prepared to receive quite small subscriptions for buying Mr. Forbes' pictures for a gallery of modern art in Dublin, I shall be glad if you will accept the enclosed cheque for one guinea for this purpose', signed, 'Sarah Cecilia Harrison, 33 Harcourt Street, Dublin'. On 15 December 1904 the paper reported that a Ladies Committee had been formed to collect money for the pictures offered, and the working committee included the Countess Markievicz, who was one of two secretaries. A further letter appealing for funds and support appeared in the *Irish Times* on 5 January 1905, signed by, among others, Lady Gregory, W.B. Yeats, Æ, Jane Barlow, Douglas Hyde, Edith Somerville, Emily Lawless and Sarah Cecilia Harrison.

By 25 June 1906 the *Belfast Newsletter* had reported that 'Thanks to the energy of Miss S.C. Harrison a petition has been extensively signed to the Royal Commission on Art Institutions urging consideration of a scheme for establishing a gallery of modern art in Dublin'. This was in the wake of Lane's loan exhibition in Belfast's Municipal Art Gallery in April and May 1906 which contained 143 works, described by Lane as being the most representative exhibition of modern painting yet seen in Ireland; along with Corot, Constable, Monet and Manet, Irish artists included Orpen, Lavery, Osborne and Sarah Cecilia Harrison. The intention was to encourage the city to purchase the fifty or so works that were for sale but Belfast Corporation were reluctant to commit and interest in the proposal petered out.[2] In recognition of Lane's efforts in both Dublin and Belfast, a public acknowledgement of his services in the form of a commissioned portrait of Lane by John Singer Sargent was presented to him on the afternoon of 11 January 1907 at a ceremony in Dublin's Hibernian Hotel;

2 Robert O'Byrne, *Hugh Lane 1875–1915* (Dublin, 2000), pp. 85, 86.

Sarah Purser
Miss Jane Barlow, 1894

Boleslaw von Szankowski
Countess Constance Markievicz, 1901

Harrison was among the subscribers listed in the *Irish Times* report of the occasion. An accompanying framed testimonial contained watercolour illustrations by, among others, Æ, Sarah Cecilia Harrison, Richard Caulfield Orpen and Nelly O'Brien, sister of Lane's friend Dermod O'Brien.[3]

An important, though unlikely, ally of both Sarah Cecilia Harrison and the gallery campaign was Alderman Thomas Kelly. Kelly had been put up as a candidate by the Dublin Workmen's Club and Abstinence Association of 41 York Street and elected a member of the Municipal Council in January 1899, representing the Mansion House Ward. These Local Government elections followed on from the Local Government Act of 1898[4] which permitted women and those with very little property to be included as candidates. As a result, a number of new councillors, Kelly among them, focused their attention on the dire housing conditions in Dublin at the time. In February 1905 the Municipal Council authorised the Estates and Finance Committee to provide the sum of £500 per annum to maintain a gallery for the collection of pictures offered to the city by Lane. The proposal was then referred to the Public Libraries Committee, of which Kelly was Chairman. From then on, Kelly was to become closely involved in the gallery proposal and, although progress would be slow, the hunt started for temporary premises for the collection which, in the meantime, was housed at the Royal Hibernian Academy in Lower Abbey Street. A fine eighteenth century house, the former residence of Lord Clonmell, Chief Justice, at 17 Harcourt Street was selected. In early September 1907 a special meeting of the Corporation was called at which Alderman Kelly made a long, colourful speech urging acceptance of the premises and the proposal was accepted with only one dissenter.[5] A sub-committee was formed to run the Gallery, with Lane as Honorary Director.

The new Gallery of Modern Art eventually opened at 17 Harcourt Street (Clonmell House) on 20 January 1908. The invitation card, in both Irish and English, was sent in the name of Alderman Kelly, who presided over the opening ceremony. He expressed his deep gratitude to Lane's vision in his proposal which had finally come to fruition. In the *Daily Mail* on 21 January there was a full description of the opening:

> Ald. Kelly, who presided, is one of the Sinn Féin Leaders. From the same platform
> in perfect harmony could be heard Lord Drogheda (a Conservative Irish Peer), the

3 *ibid*. p. 87.
4 Sheila Carden, 'Alderman Tom Kelly and the Municipal Gallery',
 Dublin Historical Record, vol. LIV, no. 2 (Autumn 2001), p. 116.
5 *ibid*. p. 120.

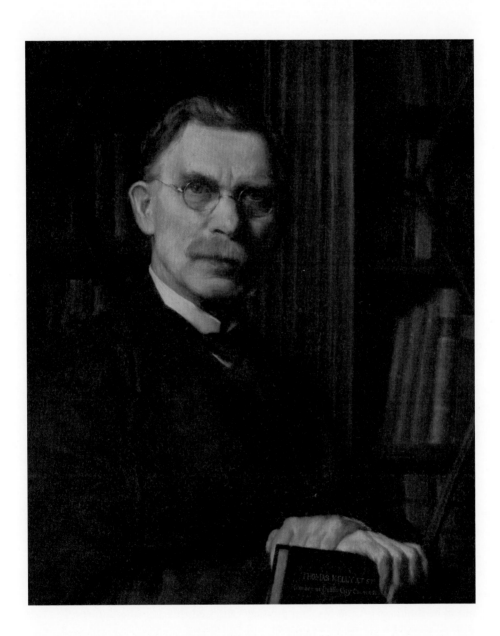

Sarah Cecilia Harrison
Alderman Thomas Kelly, 1925

Lord Mayor, Ald. Cotton, a Nationalist and a Labourite; Dr. Mahaffy, one of the shining lights of the Protestant Church, and Fr. Finlay, of the Society of Jesus.[6]

The fact that individuals from such diverse persuasions and political backgrounds had united in support of the provision of a modern art gallery for Dublin was clearly a source of wonderment.

Lane wrote the preface to the catalogue and Sarah Cecilia Harrison wrote the catalogue entries. 'Social Notes' from the time report that at the opening 'Countess Markievicz's brown dress was worn with a green hat adorned with a cluster of shaded pink roses at the side… Miss Harrison was entirely in black and she had a large picture hat with long net veil.' After the Gallery opened Harrison was deeply involved in its administration and showed distinguished guests, such as the Lord Lieutenant and Lady Aberdeen, around the rooms if Lane himself was unavailable. Harrison's self-portrait was included in the exhibition and by December her 1908 double portrait of Thomas and Anna Haslam was also hanging. The Haslam portrait depicts an unusual and fascinating couple who devoted their lives to the promotion of women in education and local and national government. In 1876 Anna Haslam had founded the Dublin Women's Suffrage Association, which later became the Irish Women's Suffrage and Local Government Association (IWSLGA). Francis Sheehy Skeffington and his wife Hanna were members. It had about 500 members by 1914 but its commitment to constitutional methods and anti-militancy stance deterred younger women, who joined the more strident and militant suffrage organisation, the Irish Women's Franchise League (IWFL), founded in 1908 by a group led by Hanna Sheehy Skeffington and Margaret Cousins. Harrison was a member and regular speaker at public meetings. However, both Irish suffrage societies were united as tensions between nationalists and unionists grew with the increasing likelihood of Home Rule being implemented and all agreed that if Home Rule came it should include women's suffrage.[7] The Irish Parliamentary Party refused to commit to support for this, for fear of destabilising the Liberal government and endangering the Third Home Rule Bill introduced into parliament in 1912. The IWFL turned to militancy in the form of breaking windows in public buildings; Anna Haslam publicly criticised this as being unhelpful to the suffrage cause yet she visited Hanna Sheehy Skeffington in Mountjoy Jail, explaining 'I am not here in my official capacity, of course… but here's some loganberry jam –

6 ibid. p. 121.
7 Mary Cullen, 'Anna Haslam's Minute Book' (2009),
 www.nationalarchives.ie.

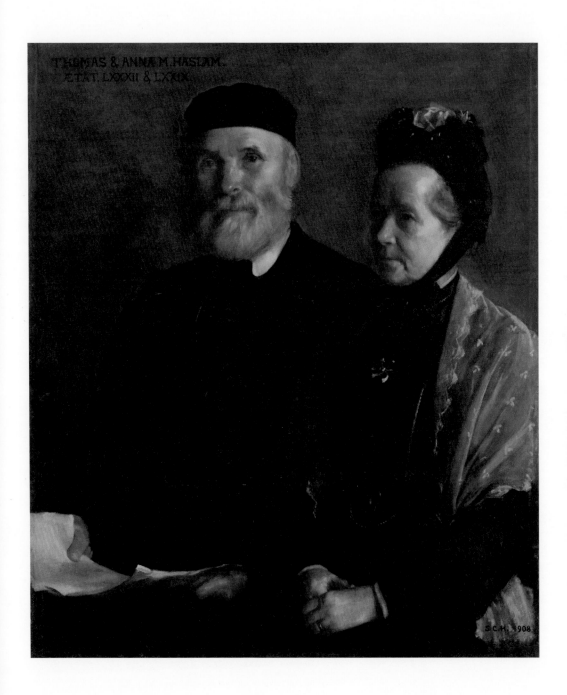

Sarah Cecilia Harrison
Mr and Mrs Thomas Haslam, 1908

I made it myself'. In May 1913, at a protest against the Prisoners (Temporary Discharge for Ill Health) Act (known as the 'Cat and Mouse Act') being used against hunger-striking suffragettes, Harrison insisted that to condone persecution for political views was against popular liberty. Having been heavily involved in the constitutional struggle for votes for women which had finally been realised in 1918, in December of that year she was a prominent figure in the suffrage victory procession escorting Anna Haslam to vote in William Street, Dublin.

Both Harrison's self-portrait and *Mr and Mrs Thomas Haslam* were extensively praised. In the Dublin *Evening Telegraph* on 14 December 1908, Ellen Duncan stated:

> On the staircase well will be found the double portrait of Mr. And Mrs. Thomas Haslam by Miss S.C. Harrison which was exhibited at the Royal Hibernian Academy last Spring. This fine work, so powerful and direct in handling, so rich in observation, reveals not alone the precision of touch of the brilliant executant but the imaginative insight of the true portrait painter.

Thomas Bodkin, Lane's friend and a future director of the National Gallery, also expressed his deep admiration for the works. Later in 1908, Lane arranged that a number of pictures by Irish artists were included in a Franco-British exhibition at London and Harrison's exhibits in this show included the Haslam double portrait.

Despite the success of its opening, the gallery project soon began to run into financial problems and on 21 January 1908 the City Treasurer said that he expected the Finance Committee to cease any payments for maintenance of staff or wages at the new gallery.[8] Kelly persisted, however, and the Gallery remained open, thanks to private subscriptions which continued, as did donations to the collection. The *Irish Times* on 29 September 1908 noted:

> We have all good reason to be proud of the Municipal Art Gallery. Established only a few months ago by the great enterprise and enthusiasm of Mr. Lane, it has already more than justified its existence. The opening ceremony was in its way one of the most remarkable events in the annals of the city. It provided a platform on which Irishmen of all political parties and all social grades met for the common purpose of promoting a truly national object. The Corporation has

8 Carden, 'Alderman Tom Kelly', p. 122.

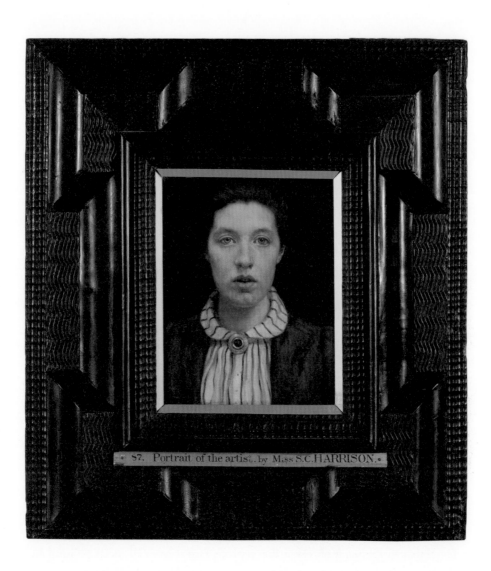

87. Portrait of the artist by Miss S.C.HARRISON.

Sarah Cecilia Harrison
Portrait of the Artist, 1900

taken a consistent interest in the Gallery and has helped in many substantial ways. Leading Irish Unionists have been among Mr. Lane's most generous supporters and, led by Alderman Kelly, the Sinn Fein Party gave the Gallery its most cordial blessing.

In 1908 Lane was awarded the Freedom of the City of Dublin and in 1909 he received a knighthood.

Further criticisms were levelled at the Gallery and the cost of financing it in straitened times. One of its most trenchant critics was William Martin Murphy, a wealthy businessman and proprietor of the *Irish Independent*. He was also associated with the *Irish Catholic*, another critic of the Gallery. Murphy was a supporter of Home Rule but strongly opposed Parnell. Meanwhile, the *Irish Times* of 13 July 1912 reminded the public that only six months remained for suitable accommodation to be found for the Gallery, because the Harcourt Street premises was only a temporary arrangement. Harrison, who continued to be a loyal supporter to Lane's cause, was one of the twenty-one signatories to a letter to the *Irish Times* on 19 November 1912 which suggested a public meeting to discuss the issue. When the meeting took place on 29 November, it was apparent that Dublin Corporation could not meet the entire cost of the Gallery, although the Lord Mayor, Lorcan Sherlock, stated that, if funds provided by the public were sufficient to acquire a site, he believed that the Corporation would provide funds for the erection of the Gallery and an annual sum of £1,000 for its maintenance. Alderman Kelly also spoke and dealt with the criticism regarding the money spent on the Gallery, stating that, as a member of the working class himself, he believed that they could also contribute to the artistic progress of Dublin. As a result of this meeting, the Mansion House Committee, with Harrison as secretary, was formed, with the aim of raising funds for the new Gallery. The heterogeneous nature of those involved in the project was again noted by the *Freeman's Journal* on 2 December 1912 when it observed that representatives from all social, political and religious backgrounds were united in the aim of establishing the Gallery.

In the *Daily Herald* of 6 December 1912, Francis Sheehy Skeffington reported 'Ald. Kelly, whose racy speech was much enjoyed, discussed the objection that so much money might be better expended on the slums of Dublin. He did not agree with this view, he held that life would be made better worth living by offering the poor the

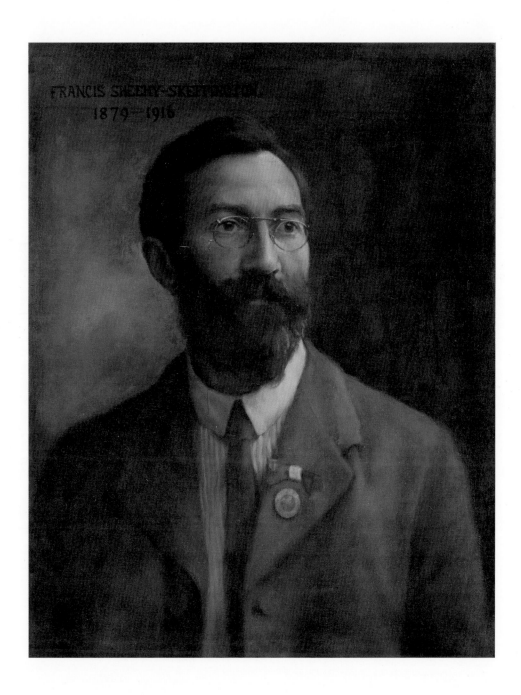

Sarah Cecilia Harrison
Francis Sheehy Skeffington, 1916

means of mental elevation.' A further impassioned article by Sheehy Skeffington on the subject of the Gallery appeared in the *Daily Herald* on 10 January 1913:

> Do not let us be told that Ireland is a poor country and cannot afford the sum required. Side by side with the festering poverty of our slums and extracted from it, there is abundance of money to spend on luxury and ostentation, benefiting neither society nor the individual. There are men in Dublin who could as easily spare out of their unearned increment, a thousand. How many of them have done so?… What are the upholders of this mammonised morality doing to preserve intact for the city and for the nation a property which, priceless from the point of view of culture, will even from the most commercial of standpoints, grow in value, year by year.

In January 1912 Harrison was the first woman to be elected to Dublin Corporation, heading the poll as an independent candidate for the South City ward, supported again by Alderman Tom Kelly. At the time of her election Harrison was living at 13 Harcourt Street but sometime during 1912 she moved to 14 North Frederick Street. As an ardent nationalist and feminist with a strong social conscience, she was a frequent contributor to the left-wing *Irish Citizen* and in 1909 became secretary of the Dublin City Labour Yard, which gave employment to those who failed to secure relief from Dublin Corporation's distress committee.[9] The plight of the unemployed was her abiding concern and one of her first actions as a newly elected Councillor was to initiate an inquiry into the activities of the Corporation's distress committee. This resulted in bitter exchanges between Harrison (who had no legal representation) and the Corporation's legal team. At other meetings of Dublin Corporation she argued for equal pay for female corporation employees and for an inquiry into police brutality during the 1913 lock-out in Dublin. Housing for the poor was her particular interest and she argued the case of slum dwellers before the Dublin housing inquiry of 1914. She also strenuously criticised any form of persecution for political views. Having served as a Councillor for three years she eventually lost her seat in the election of January 1915.

Nevertheless, her commitment to social causes continued and she became heavily involved in the allotments movement. Although she had first founded the movement

9 Diarmaid Ferriter, entry on Sarah Cecilia Harrison in *Dictionary of Irish Biography Online*, Cambridge University Press and Royal Irish Academy, 2010.

in 1909, it made little progress until Dubliners began to experience chronic food shortages from 1915 onwards.[10] Harrison became Honorary Secretary to the Dublin Vacant Land Cultivation Society and in January 1916 organised, by arrangement with Dublin Corporation, a draw among Dublin working men and women to allocate eighty allotments for growing garden vegetables at Fairbrothers' Fields near Dolphin's Barn. By 1919, 440 acres of waste ground, vacant building sites and parkland were under cultivation by 3,000 plot holders, with a further 2,000 applicants for plots on the Corporation waiting lists. The movement crossed political and religious divides and played an important role in educating Dubliners in popular democracy.

Harrison's commitment to the Gallery of Modern Art continued and on 16 January 1913 the *Irish Independent* published her letter arguing the case for the paintings. However, many, including William Martin Murphy, queried the expense of building a special gallery to house a loan collection of works, saying that Corporation funds were more urgently needed to replace the slum dwellings in the city. To this Harrison retorted that building a gallery would give work to the poor of Dublin. Kelly also attacked Murphy's stance, asking what he had ever done for the housing of the poor. Furthermore, on 1 February 1913 a letter appeared in the *Irish Catholic*, signed by Harrison and Alderman Tom Kelly, assuring the public that the 'loan pictures' would become public property when a new gallery was built.

By this time, it had been proposed to build the Gallery on a bridge over the river Liffey; in a letter to the *Evening Herald* Murphy again voiced his objections to this proposal. A long newspaper correspondence on the issue followed, with Murphy attacking the proposal and Harrison defending it. Controversy also surrounded the choice of Edward Lutyens as architect with W. T. Cosgrave proposing that Lane should be informed that Irish architects must be able to compete for the design before the Council could proceed (although Lutyens's mother, like Lane's mother, was Irish by birth). Kelly also agreed that local Irish architects should be free to compete. Harrison justified her position by stating that, while she understood Alderman Kelly's and the other councillors' stance, Lane wanted Lutyens because he was the greatest living architect. The motion was eventually defeated at a meeting on 19 September and at the end of October the newspapers reported that the subscriptions to the Mansion House fund were being returned to the donors. Over £12,000 had been collected, and before it dissolved the Committee recorded its regret at the final decision which

10 Padraig Yeats, 'War & Society: Oh what a lovely war! Dublin and the First World War', *History Ireland*, vol. 19, no. 6 (November / December 2011), p. 23.

'deprived the city of a unique and most valuable gallery of modern art.' Harrison must have been personally saddened by this outcome but she continued to paint portraits (including one of Hugh Lane) and exhibit regularly. Her correspondence with Lane also continued; her letters reveal that their friendship was close and to an extent she was his confidante. Lane's death on the Lusitania in 1915 was devastating for her and she did not exhibit any works for five years following the tragedy.

Lane's will, dated 11 October 1913, was in the custody of his sister, Ruth Shine. This bequeathed to the National Gallery in London the pictures which had been offered to Dublin. A further search, initiated by Lady Gregory, led to the discovery of an unwitnessed codicil dated 3 February 1915. In the weeks after his death, Harrison continued to see Lane's sister, Ruth Shine, because over the years a friendship had developed between the two. However, relations cooled immediately, when Harrison claimed that she had been secretly engaged to Lane (twelve years her junior) and that they had intended to marry in the summer after his return from the United States. Harrison did not accept that the will of 1913 or the codicil of 1915 were genuine and believed that a genuine will existed but had disappeared or been concealed by Lane's relatives. However, she took no legal action to contest the 1913 will, which was accepted. Lane had left Harrison £100 and a piece of jewellery which she refused to accept.

To an extent, Harrison's reputation was damaged by her assertion that she had been engaged to Hugh Lane and there is no doubt that many found her approach irritating, including Hugh Lane at times. In late July 1913, in the midst of the debate surrounding the bridge site, Lane wrote from Dublin to Lady Gregory, who incidentally disliked Harrison, 'Miss Harrison is extraordinarily unpopular here. Everyone is admitting her unselfish devotion to the cause, but she is very tactless – has many "bees in her bonnet"!'.[11] However, despite this, after Lane's death Harrison still remained a stalwart in a campaign to have the codicil recognised and the paintings returned to Dublin. In spite of their differences, on 30 January 1918 Harrison and Lady Gregory appeared on a platform at a public meeting in the Mansion House where Harrison told the audience that Lane wished the paintings to go to Dublin. Lady Gregory noted in her diary in June 1923:

> Today W.B.Y. has a letter from Miss Harrison making a 'last appeal' to him to come and see her (about the codicil)… I thought it dangerous and made him

11 Hugh Lane to Lady Gregory, 31 July 1913, The Henry W. and Albert B. Berg Collection, New York Public Library, as quoted in O'Byrne, Hugh Lane, p. 225.

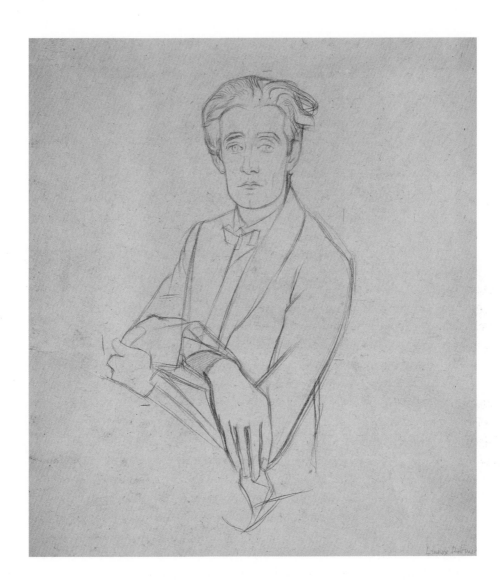

William Rothenstein
Study for Portrait Drawing of Lennox Robinson,
c. 1921

show it to her brother, who with much reluctance has promised to see her about it, says he has not seen her for months and that whenever he has any discussion with her he 'wants to bash her head'. Lennox Robinson says she told him straight and plain that I had forged the codicil…[12]

While the dispute regarding Lane's will remained a private matter between her and the family, in 1926 Harrison wrote a pamphlet entitled 'Inquiry concerning the continental pictures of Sir Hugh Lane: The Next Step' (published 1927), stating that in 1924 she had drawn up a statement in the form of a statutory declaration which questioned the validity of the bequest to the National Gallery in London on the evidence of Hugh Lane's letters to her before and after 11 October 1913.[13] She also wrote that the unwitnessed codicil of 3 February 1915 was incompatible with a statement about the Gallery that Lane had made to her two weeks before that and also contrary to intentions expressed by Lane to Alderman Tom Kelly in the first week of February 1915. Furthermore, she claimed that a collection of documents dealing with the subject had been stolen from a locked desk in her home.[14] When Dublin Corporation appointed Harrison a member of the official Lane Bequest Claim Committee, Lane's friend Thomas Bodkin wrote to Lady Gregory, 'I thought it peculiarly disgraceful in view of her various crazy pronouncements on the subject of the will.'[15] In the same year, Lane's former banker commented to Ruth Shine, 'Miss Harrison seems to be on the warpath again. I can't be bothered with her. Then I don't think anyone else can either.'[16]

However, Harrison's stance regarding Lane had led to her increasing isolation from his friends and family and in 1919 she alone asked Lutyens to design a memorial tablet to commemorate Lane. In 1929 she requested permission to have it erected in St Ann's Church on Dawson Street, Dublin, where it is now on display on the wall. She was also secretary of the committee which placed the Haslam memorial seat in St Stephen's Green in 1925. During the 1920s and 1930s Harrison continued to paint portraits and exhibit regularly at the Royal Hibernian Academy. She moved to 7 St Stephen's Green around 1923 and this was her home for the rest of her life. She continued to campaign for the needy and regularly listened to the grievances of the poor of Dublin who visited her in her home. Up until her death in 1941 she kept a keen interest in politics and was a regular visitor to Dáil Éireann. At six feet tall, she was a striking figure. Harrison died at a nursing home in Drumcondra on 23 July 1941

12 Marie O'Neill, 'Sarah Cecilia Harrison: Artist and City Councillor', *Dublin Historical Record*, vol. XLII, no. 2 (March 1989), p. 78.
13 *ibid.* pp. 76, 77.
14 O'Byrne, *Hugh Lane*, p. 227.
15 Bodkin to Lady Gregory, 18 January 1932, National Library of Ireland [NLI], Ms 35,825/1 (3).
16 John Meagher to Ruth Shine, 14 January 1932, NLI, Ms 35,824/8 (1–7).

and is buried in Mount Jerome Cemetery, where a granite cross over her grave reads 'Sarah Cecilia Harrison 1863–1941. Artist and Friend of the Poor'.

Without question, Harrison's role in the establishment of the Municipal Gallery has been overshadowed by her claim that she was secretly engaged to Hugh Lane. The antipathy of Lady Gregory and some other individuals towards her has also contributed to her reputation being somewhat tarnished by her claim. No correspondence exists that can confirm that her relationship with Lane was anything more than that of a close friend and supporter. Without doubt, as the question of the establishment of a permanent gallery of modern art led to much negotiation, discussion and controversy, throughout her life Harrison remained a stalwart supporter of Lane and the Municipal Gallery. It is a fitting tribute to Harrison's fine work as a portraitist that the Gallery has thirteen works by the artist in its collection and posthumous appreciation of her contribution to the cultural life of Dublin is richly deserved.

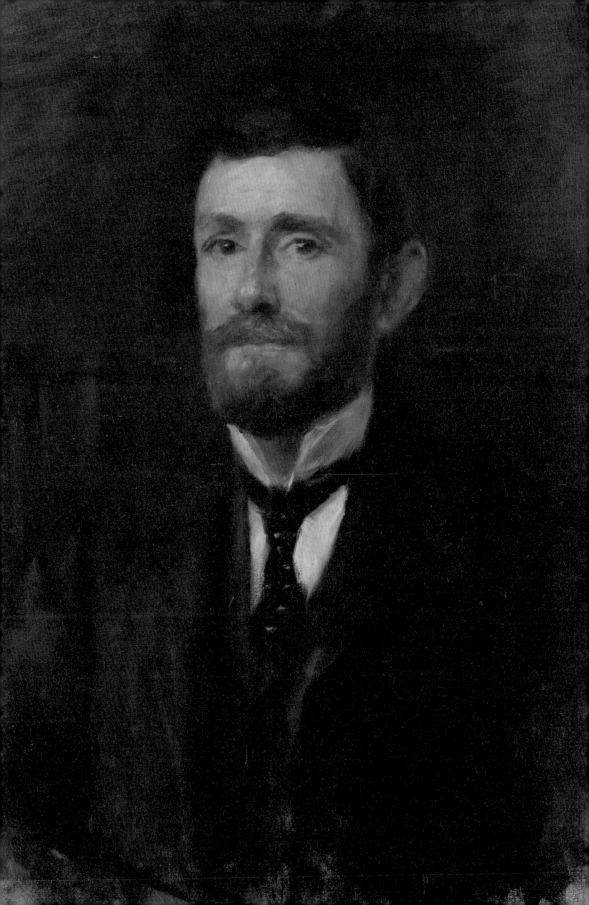

Marking the Introduction to the British Parliament of the Third Home Rule Bill, April 1912

P.J. Mathews

W.B. Yeats was never reticent about placing himself at the centre of events in the Ireland of his time. In his reflections on the progress of Irish history he liked to argue that as a result of the general disenchantment within nationalist Ireland in the period after Parnell's death in 1891, political energy was diverted into cultural channels, creating a dynamic for revolution. As he put it himself in *Autobiographies*:

> A disillusioned and embittered Ireland turned from parliamentary politics; an event was conceived; and the race began, as I think, to be troubled by that event's long gestation.[1]

Undoubtedly, Yeats overstated the extent to which he and his Revivalist contemporaries lit the torch that would eventually explode in Easter Week 1916. Yet the fact remains that, in the run-up to those revolutionary events, a great deal of innovative political activity took place outside the purview of the main constitutional parties and within the domain of a coalition of newly evolving Revivalist 'self-help' movements. Although these self-help organisations professed to operate beyond conventional party politics, their activities clearly had political ramifications. Surveying this period, therefore, one can detect a developing fault-line in Irish political life between an emergent self-help consensus and an old-style belief in Westminster parliamentary politics.

In truth, the period between 1893 (the year of the defeat of the Second Home Rule Bill) and 1912 represented a particularly dark and powerless period for

John Butler Yeats
The Right Honourable Sir Horace Plunkett, KCVO, c. 1905
(detail)

1 W.B. Yeats, *Autobiographies* (London, 1955), p. 559.

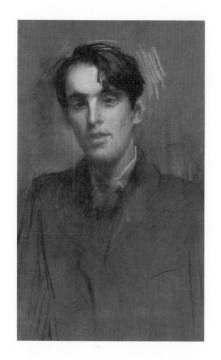

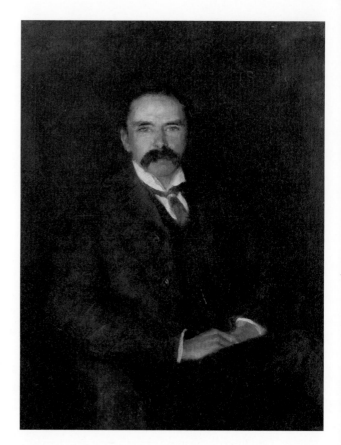

Sarah Purser
W.B. Yeats, c.1904

John Butler Yeats
Dr Douglas Hyde, LL D, c.1904

constitutional politics in Ireland. James Joyce caught this inertia perfectly in 'Ivy Day in the Committee Room' – a story in which he satirises the inadequacies of a political culture almost totally bereft of any commendable strategy to better Ireland's lot. The prevailing mood of the narrative is one of an intoxicated nostalgia for the glory days of Parnell and, in typical Joycean fashion, it brilliantly encapsulates the bankruptcy and dark frustrations of that moment.

With the realisation that little could be achieved at Westminster and a weariness of the divisive squabbling of Irish politicians in the wake of Parnell's demise, a new generation of Irish intellectuals and artists came up with the strategy of working for a form of *de facto* Home Rule, despite its unattainability *de jure*. The plan was to mobilise and apply the latent national intelligence of the country to the practical needs of Ireland – a strategy conveniently encapsulated in the term 'self-help'. Central to the endeavour was the belief that Ireland had accepted London as the centre of culture and civilisation for too long, and that the time had come for the Irish people to regenerate their own intellectual terms of reference and narratives of cultural meaning.

It is no accident that the emergence of two of the most important self-help movements to revolutionise the social, economic and cultural practices of Ireland coincided with the defeat of the Second Home Rule Bill: the Gaelic League in 1893 and the Co-operative Movement in 1894. Yeats had already set the ball rolling with the National Literary Society in 1892, the Irish Literary Theatre (the precursor of the Abbey Theatre) was founded in 1899, and a women's movement, Inghinidhe na h-Éireann, was established in 1901. Significantly, there was quite a degree of overlap at both executive and grassroots level between these movements.

Indeed, many of these initiatives were calculated responses to Douglas Hyde's famous essay 'The Necessity for De-Anglicising Ireland'. In this blueprint for an Irish Revival Hyde argued that an uncritical acceptance of the forces of Anglicisation had had a debilitating effect on the Irish people, causing them to become slavish imitators of English fashions and incapable of cultural innovation. In such a scenario, according to Hyde, the Irish were destined to be consumers of someone else's culture rather than producers of their own. From his point of view, it was the loss of the language rather than its revival that condemned the Irish to be forever provincial.

One of the most successful of all the self-help initiatives was Horace Plunkett's Co-operative Movement, which was founded to improve the economic lot of

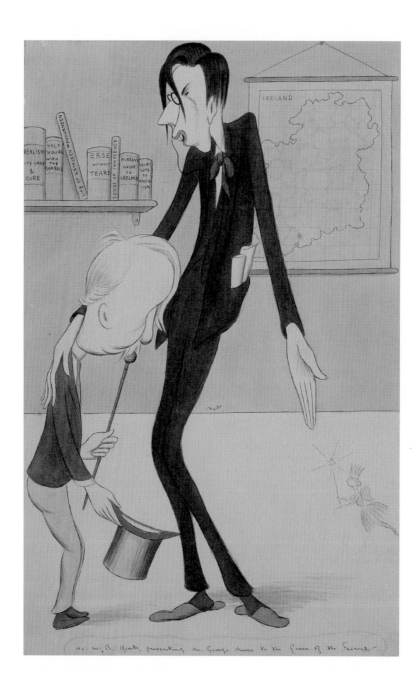

Sir Max Beerbohm
Mr W.B. Yeats Presenting Mr George Moore
to the Queen of the Fairies, c. 1904

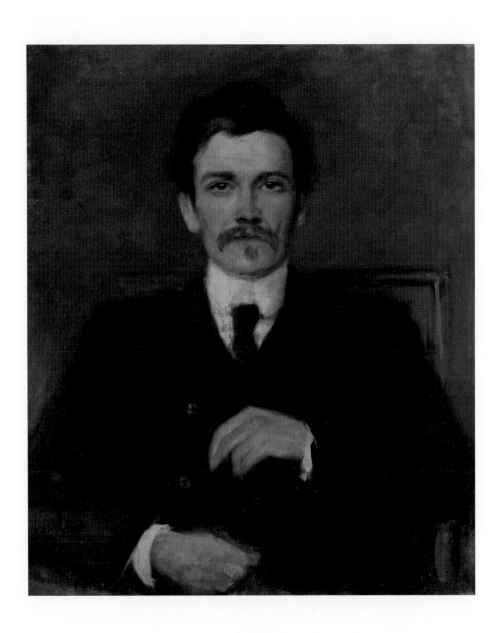

John Butler Yeats
John Millington Synge, c. 1905

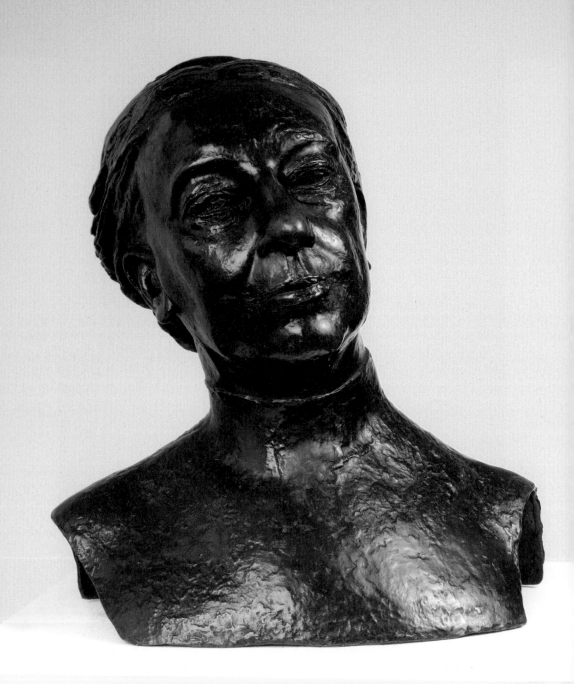

small farmers. Plunkett realised that although the majority of farmers now owned their own land, most of them lacked the expertise to compete in increasingly sophisticated and mechanised agricultural markets. Perhaps more significantly, the co-op movement also allowed many small farmers to break free of the economic stranglehold of the gombeen publican-shopkeepers so prevalent at the time. Plunkett, too, taking a lead from Douglas Hyde, was firm in the belief that Ireland could only recover economically if it was culturally self-assured. To this end he endorsed and repeatedly drew attention to the work of the Gaelic League and lent his support to the Abbey Theatre.

The extent to which the co-op societies contributed to the intellectual and artistic life of Revival Ireland, however, has been under-acknowledged in recent times. One of the chief organisers of the co-op project was George Russell, the poet, painter and mystic also known as Æ. In many ways he is a quintessential Revival figure who did not see any contradiction between his economic ideas on agricultural co-operation and his artistic interests. He edited the organisation's journal, *The Irish Homestead*, which devoted a considerable amount of space to cultural matters. In this remarkable publication it was not uncommon to see a poem by Yeats or a short story by James Joyce published side-by-side with an article on fertilisers or on how to treat cattle with scour.

It is remarkable how quickly the self-help Revivalists succeeded in eclipsing the constitutional politicians in securing material and political gains for Ireland into the first decade of the century. It was out of the success of the Co-operative Movement that Horace Plunkett managed to secure a Department of Agriculture for Ireland in 1899, providing *de facto* Home Rule for Irish agriculture; while the Gaelic League through its agitation succeeded in attaining a higher recognition for the Irish language in the education system. Even the most cultural of the Revivalist initiatives – the literary movement – succeeded not only in producing Irish literature and drama, but also in founding significant institutions such as the National Literary Society and the Abbey Theatre. W.B. Yeats, Lady Gregory, George Moore and Edward Martyn were not only influential artists in their own right but were also the unofficial arts planners and arts administrators of their day.

As a playwright, an essayist and a grassroots organiser Augusta, Lady Gregory, was a key contributor to the self-help project and was one of the first to identify the new zeitgeist as it was taking hold. She repeatedly drew attention to the extent to which the self-help movements had eclipsed the Irish members at Westminster as the major

Jacob Epstein
Lady Gregory, 1910

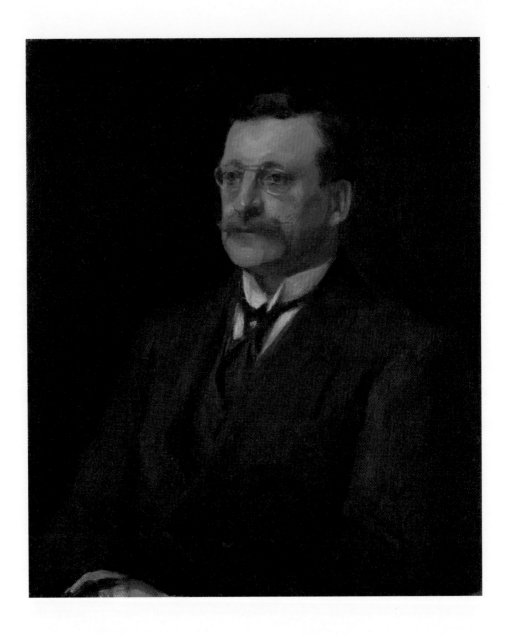

Lily Williams
Arthur Griffith, c. 1920

force for change in Ireland. Likewise, John Millington Synge, the most gifted of the Abbey playwrights, identified the loose coalition that existed between the co-operative associations, the Gaelic League and the literary movement as a progressive alliance. 'These three movements', he wrote, 'are intimately linked; it is rare to find someone who is interested or active in one ... who is not also concerned with the others'.[2] In contrast, Synge despised what he called 'the groggy-patriot-publican-general-shop-man who is married to the priest's half-sister and is second cousin once-removed of the dispensary doctor' – an analysis very close to that offered by Joyce in 'Ivy Day'.

Given the inertia of constitutional politics at this time, it is hardly surprising that the Revival would eventually produce a movement that would take the self-help ethos to its most radical conclusion by advocating an alternative politics. Sinn Féin's answer to the Home Rule question was to give up seeking the sanction of the British and to get on with the business of setting up a parliament in Dublin by unilaterally withdrawing Irish members from Westminster. Significantly, by 1909 the major cultural, political and educational institutions of the future Irish State – the Gaelic League, the Abbey Theatre, Sinn Féin and the National University of Ireland – had all been established, largely due to the efforts of the Revivalists and with little help from mainstream politicians.

With the passage of nearly two decades between the defeat of Gladstone's Second Home Rule Bill in 1893 and the introduction of the ill-fated Third Home Rule Bill to the British parliament in April 1912, the dynamics of Irish nationalist politics had changed irrevocably, due, in no small part, to advances made by the new self-help movements across the country and the taking hold of the main ideas of the Revival. The 1912 Home Rule Bill certainly engendered a flurry of extra-parliamentary activity in Ulster, as unionists sought to resist the proposed constitutional changes. However, the scale of self-help activity across Ireland over the preceding two decades represented a repudiation of the British parliament for very different reasons. With war between the major European powers looming, it seemed less likely that a political settlement consisting of Home Rule within the Empire would unquestionably satisfy the expectations of nationalist Ireland.

2 J.M. Synge, *Collected Prose* (London: Press, 1966), p.283.

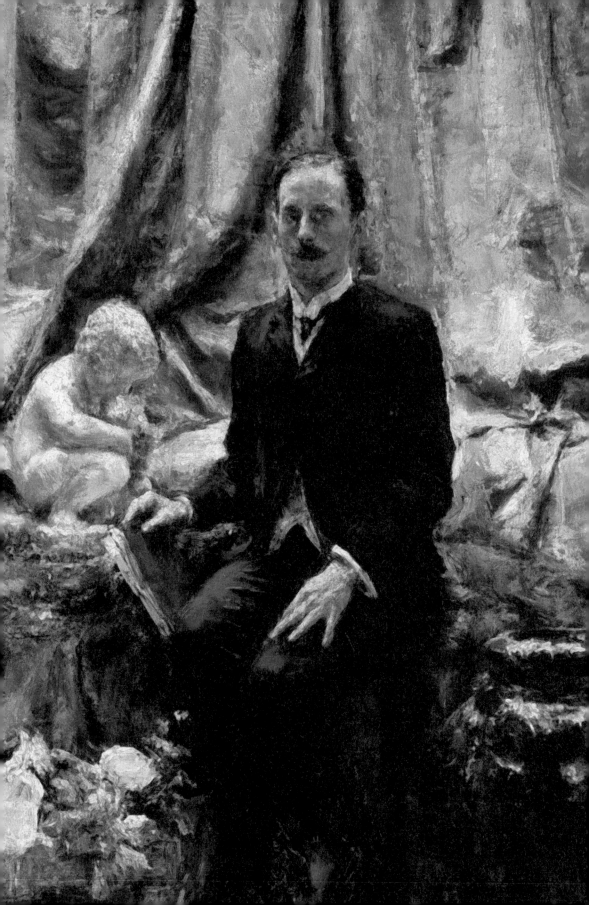

'On Behalf of Art in Ireland'[1]

Barbara Dawson

John Redmond's Irish Parliamentary Party supported by H.H. Asquith's Liberal government saw the Third Home Rule Bill introduced in the House of Commons in April 1912, a culmination of some thirty years of endeavour. The Bill was delayed in the House of Lords and did not receive Royal Assent until 1914. Six years earlier, in Dublin, Hugh Lane succeeded in establishing the first gallery of modern art in these islands, which attracted significant national and international acclaim. These events and their consequences, many of which were unexpected, helped to shape the identity of modern Ireland.

The political desire for self-determination and national identity alongside the rise of modernism in Europe was mirrored in Sir Hugh Lane's vision for a modern Ireland. This was mediated in his professional career in Ireland as the 'soft wax'[2] of political events unfolded in the early years of the twentieth century. Hugh Lane's project to create a climate for a vibrant modern art practice in Ireland and an independent Irish identity in the visual arts was supported by a series of exhibitions which he organised in Dublin, Belfast and London between 1902 and 1914. His supreme achievement, establishing a gallery of modern art for Dublin to encourage and inspire contemporary art practice, was realised in 1908 when Lane was only thirty two.

Home Rule was shelved because of the outbreak of the First World War and Ireland was partitioned in 1922. After Hugh Lane's death aboard the Lusitania in 1915, the ownership of his 'Dublin Pictures' – the core collection of the Gallery of Modern Art in Dublin – became the subject of a long running controversy between

Antonio Mancini
Portrait of Sir Hugh Lane, 1904
(detail)

1 Hugh Lane to Lord Dudley, 22 May 1904, National Library of Ireland [NLI], Ms 35,822 (1–30).
2 W.B. Yeats described Ireland in this period as 'like soft wax' and predicted it would be for years to come. See W.B. Yeats, *Autobiographies* (London, 1955), p. 199.

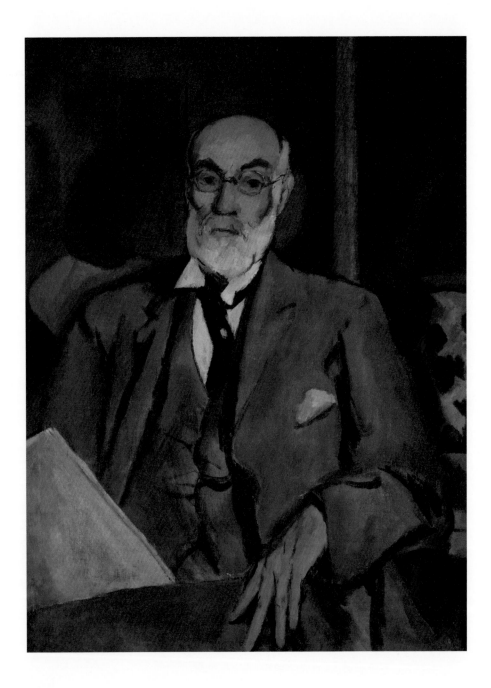

Walt Kuhn
Portrait of John Butler Yeats RHA, 1917

The Hugh Lane and The National Gallery, London, with the latter gaining ownership of them following the findings of a British Parliamentary committee investigation in 1924. The pictures are now shared between the two institutions.

Much has been written of Lane's work in Ireland. What remains remarkable is the speed with which he achieved his goals. From 1901, when he purchased paintings from the Nathaniel Hone and John Butler Yeats exhibition organised by Sarah Purser, he demonstrated his wholehearted support for the visual arts in Ireland. He boosted Hone's reputation by presenting two of his paintings to prestigious collections abroad – the National Gallery of Scotland and the Musée du Luxembourg – and he commissioned John Butler Yeats to paint a series of portraits of distinguished Irishmen and women at a time when local patronage was so poor that the artist was contemplating returning to London. Yeats described Lane 'as an artist in social life. When I lived in Dublin existence was feverish. There was the craziness of greed and of selfishness, the political craziness and of course the perpetual war between the good artists and the bad artists. All this was so much amusement to him, and to me when I was in his company'.[3]

In 1902, Lane organised a Winter Exhibition of Old Master paintings at the Royal Hibernian Academy drawn from collections from all over Ireland, which was part of his plan of support for artists. In the *Irish Times* in October 1902 he explained that if the exhibition was successful it '… would… eventually encourage modern painting in Ireland.'[4] The exhibition was very successful and he proposed a second Winter Exhibition in 1903, of work by contemporary artists. This time he ran into difficulties with the Academicians. The RHA insisted that the nucleus of the exhibition should be devoted to Walter Osborne, who had died prematurely earlier that year. But Lane would not compromise. In a letter in July 1903 to Sir Thomas Drew, President of the RHA, he demands full control of the exhibition apart from the assistance of Sir Thomas and boldly goes on to say 'if the RHA insist in honouring W. Osborne's wish as the nucleus of a Winter Exhibition I feel that… it will not be a success and the RHA must be entirely responsible for the expenses…'[5] Lane lost that battle. He did, however, purchase two works from the Osborne exhibition – *Mother and Child* and *Tea in the Garden* – as part of his collection for the Gallery of Modern Art.

That same year, 1903, much to his delight, Lane secured a place on the board of the National Gallery of Ireland. Appointed by the Lord Lieutenant, Lord Dudley,

3 Lady Gregory, *Hugh Lane: His Life and Legacy* (Gerrard's Cross, 1973), p.48.
4 Quoted in Robert O'Byrne, *Hugh Lane, 1875–1915* (Dublin, 2000), p.43.
5 Hugh Lane to Sir Thomas Drew, NLI, Ms 35,822 (1–30).

he took the seat of the late Viscount de Vesci.[6] Writing from his mother's house, 51 Dartmouth Square, on 25 August, to Sir Antony MacDonnell, the Permanent Under-Secretary for Ireland, Lane enthusiastically accepts the invitation to become a Governor and Guardian of the National Gallery of Ireland, 'hoping to be a useful servant in that capacity'.[7] MacDonnell, a Catholic and a Liberal, was sympathetic to Home Rule and supportive of land reform, overseeing the Wyndham Land Act of 1903. It could have been that Lane's successful activities in Dublin caught his attention and it was he who recommended Lane to Lord Dudley.

Undeterred by RHA rejection, Lane looked for alternative venues for his exhibition of modern Irish art. The perfect opportunity presented itself in the form of the World's Fair in St Louis, USA in 1904. Built on over 1200 acres in the heart of St Louis, in an age of technological advancement, it was by all accounts the most beautiful and successful educational exhibition of international culture ever to be presented. As Ireland was not an independent country at the time, it could not have its own pavilion. The problem was resolved by presenting an 'Irish Village' which was underwritten financially by Thomas F. Hanley, an Irish American from St Louis, and his supporters. They worked closely with the newly founded Department of Agriculture and Technical Instruction in Dublin, where the Secretary of the Department, T.P. Gill, along with the Vice-President, Horace Plunkett, were central to the brilliant success of Ireland's contribution.[8] Lane was appointed Honorary Director of the Picture and Miniature Section and proposed an exhibition of Irish paintings and miniatures from the eighteenth century to the contemporary, alongside a gallery of Irish portraits and an octagonal room displaying 'Irish Beauties'.

However, by March 1904, alarmed at the costs of the exhibition, especially the insurance premiums, T.P. Gill wrote to the nationalist MP John Redmond, cautioning him about Lane:

> Hugh Lane, the art gallery man may come to you or other members of the party… with some ideas about the Irish exhibition at St Louis, and I warn you to be particularly careful about him. The Irish Americans, who are underwriting the Irish Section (and with whom we are cooperating) have declined to go on with this particular part of the feature of it in which Lane is interested, the pictures, owing to the excessive rates which the insurance companies have put up…

6 Minutes of National Gallery of Ireland Board Meeting, 19 November 1903. My thanks to Brendan Rooney.
7 Hugh Lane to Sir Antony MacDonnell, NLI, Ms 35,822 (1–30).
8 Homan Potterton, 'Letters from St Louis (Ireland's exhibit at the St Louis World's Fair, 1904),' Irish Arts Review, vol. 10 (1994), p. 245.

Jack B. Yeats
The Travelling Circus, 1906

Jack B. Yeats
Evening, 1907

The pictures in any case are a minor feature, although in Lane's language of course it was to be the greatest thing in all St Louis…. and they have further been rather alarmed at Lane's methods who is rather a wild man about money…[9]

The art section of the Irish Village was cancelled and the artists selected, among them Jack B. Yeats, were bitterly disappointed. It was without doubt a lost opportunity for Irish art. However the indefatigable 'art gallery man' turned to London where, with the support of Sir A.G. Temple, Director of the Corporation of London Art Gallery, he organised his exhibition of modern Irish art to tremendous success in the Guildhall. This cemented Lane's credibility with his supporters. Over eighty thousand people paid admission to visit it. Several of the artists represented either presented works for the new Gallery, or had their supporters donate them. In all, over one hundred works were pledged.

In November 1904, Lane brought back the works that were pledged and exhibited them in the RHA together with the Staats Forbes collection of nineteenth century French painting and a group of Impressionist works lent by the Parisian art dealer Durand-Ruel; all of which were for sale for the Gallery of Modern Art. The RHA exhibition attracted great attention abroad, with D.S. McColl, curator of the Tate Gallery and a champion of modern art, lamenting at London losing out on the Staats Forbes collection and praising Lane's tenacity in attempting to secure it in 'a country as poor as Ireland'. He went on to say that there was 'as much need here [England] as in Ireland for galleries of modern art of the right sort …'[10] The Athenaeum declared it 'will be the first real attempt at a representative collection of modern art to be found in the British Isles.'[11]

Even before the opening of the Guildhall exhibition, Lane was already looking for a site for a gallery of modern art. In a long letter to Lord Dudley in May 1904, he expresses his disappointment that his scheme for a new RHA building and a gallery of modern pictures in Kildare Street had come to nothing. As well as bringing together a collection for the Gallery of Modern Art, Lane points out that in order for the scheme to succeed there was need for an annual purchasing grant and suggests that if he had an official position and were not so 'young', it would be easier for him to do this work. He also notes if the RHA could temporarily house the collection a 'site would not at present be a necessity'.[12] Nothing came of his proposals. Undaunted, Lane continued

9 T.P. Gill to John Redmond, 4 March 1904, NLI, Ms 15,190/2.
10 The Saturday Review, 3 December 1904.
11 The Athenaeum, 3 December 1904.
12 Hugh Lane to Lord Dudley, May 1904, NLI, Ms 35,822 (1–30).

to purchase works for the new Gallery as well as lobby artists to present works. He was tremendously successful and a site for a gallery of modern art rapidly become a real necessity. By March 1905, the city council had allocated an annual grant of £500 for the running of the Gallery and charged the Estates and Finance Committee to identify and maintain temporary premises for the collection.[13]

The longer Dublin took to provide a site and funds for a new building to house this collection, the more Lane was wooed by London. In June 1907, Lane wrote to Sir Charles Holroyd, Director of the National Gallery London, offering his:

> … group of Modern Continental Pictures to the Tate Gallery and National Gallery. Believing that the fact of their being shown in a famous London Gallery for a few years will make the Dublin authorities realise their merit and educational value…. Two years ago they voted an amount £500 for the maintenance of such a gallery, but they now wish to direct it themselves and are insist [sic] on the control of these pictures of mine…. If it were possible for the trustees to accept them for as short a period as two years it would be well for us, as by that time I am confident that the project will be safely established.[14]

Alderman Thomas Kelly, a champion of Hugh Lane and the modern art gallery project, oversaw the acquisition of Clonmell House, 17 Harcourt Street, for temporary premises for the Gallery. Hugh Lane was appointed Honorary Director. The Gallery opened on 20 January 1908 to national and international acclaim, with Lane's Impressionist paintings singled out for particular praise. In February Lane was conferred an Honorary Freeman of the City and in 1909 he was knighted for his services to art. For the moment, the pictures were saved for Ireland.

In Dublin, the site controversy raged. Those nervous that Lane would remove his conditional gift kept in regular touch with him. His friend Thomas Bodkin recounts how Lane would frequently come to Dublin bringing additional pictures for the Municipal Gallery. When Bodkin heard of Lane's efforts in establishing a gallery of modern art in Johannesburg, he wrote to him anxiously enquiring if that city's generous treatment of him had swayed his loyalties. Lane replied '… I find that one cannot buy for two galleries (not the same sort of thing) as I want all the bargains for Dublin!'[15]

13 See Barbara Dawson, 'Hugh Lane and the Origins of the Collection,' *Images and Insights* (Dublin, 1993).
14 Hugh Lane to Sir Charles Holroyd, June 1907, NLI, Ms 35,822 (1–30).
15 Thomas Bodkin, *Hugh Lane and His Pictures* (Dublin, 1956), p. 27.

The second reading of the Third Home Rule Bill was passed in the House of Commons in May 1912 which meant that, given the abolition of the House of Lords' veto, it would only be a matter of time before the Bill became law. Amongst unionists, however, resistance to a Dublin Parliament was growing and signing of the Ulster Covenant in September 1912 saw a polarisation of Irish society and the beginnings of the concept of a partitioned Ireland. Against this political landscape, the search for a suitable site for the Gallery was proving impossible. The English architect, Edwin Lutyens, a friend of Lane's, came up with a beautiful, if classical, design for a gallery surrounded by trees and shallow ponds in St Stephen's Green. Lutyens explains, 'if wanted building seen through… trees… and then you get the frail and the stable reflected in the rippled water'. He goes on to say, 'faun nymphs or leprechauns could stand amongst the trees and Lord Ardilaun in front piazza.'[16] It was hardly to the fore of modernist architecture but Lane loved the concept. However, Lord Ardilaun could not be swayed and he rejected the proposal. Lane's detractors delighted in the difficulties that now faced the Gallery of Modern Art. Another proposal from Lutyens was to replace the Ha'penny Bridge, the Victorian iron foot bridge north of the O'Connell Street Bridge, with a Vasari-like corridor spanning the Liffey. This would resolve the problem of a site. However, the Corporation couldn't agree. In November 1912, Lane took a firm stance and wrote to the Town Clerk presenting them with an ultimatum. His 'Lane Collection' comprising his 'Continental Pictures', including superb Modern and Impressionist paintings, was to be removed at the end of January 1913 unless a decision was made on a new and suitable building. Despite huge efforts on the part of Dublin Corporation the proposal for replacing the Ha'penny Bridge was rejected. In spite of his initial threat, however, Lane waited another nine months before removing his pictures in the hope that the situation would be resolved.

In the meantime Lord Curzon, Chairman of the Board of the National Gallery, pursued the possibility with Lane of the works being gifted to London with a promise of a room for his collection. His suggestion of presenting them outright was rejected by Lane. In a letter dated 8 August, Lane says:

> The situation in regard to my pictures has not changed much. I have given the Dublin Corporation a further six weeks (from August 1st) to decide about a gallery. I still intend to lend the group that I removed to an English or Scottish

16 Edwin Lutyens to Hugh Lane, NLI, Ms 35,823/3/13 (2).

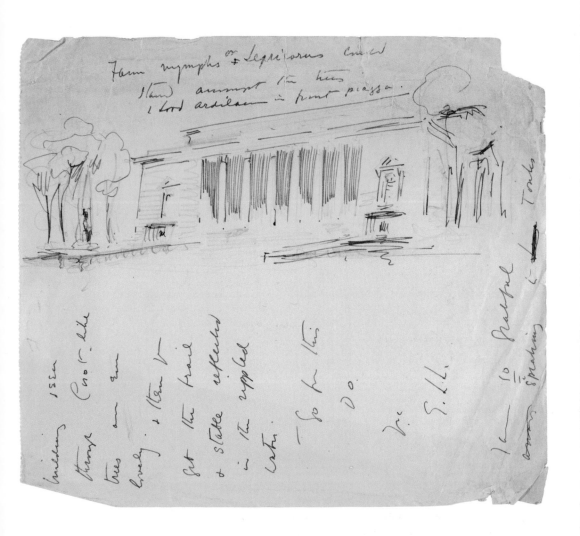

Letter from Sir Edwin Lutyens to Sir Hugh Lane,
1912, National Library of Ireland

ART GALLERY SITE IN DUBLIN ---ANOTHER SUGGESTION.

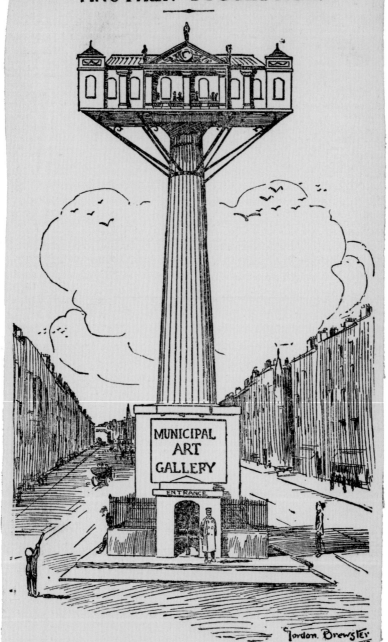

In view of the recent controversy regarding the site for a Municipal Art Gallery, our artist ventures to suggest the top of Nelson's Pillar, where it could not obstruct any view of the city.

Cartoon by Gordon Brewster which appeared in the *Saturday Herald*, 12 April 1913

The Removal of the 'Lane Pictures' to the Mansion House

Hugh Lane as caricatured by Frank Reynolds (detail of *In The Dublin Zoo*, see p.117)

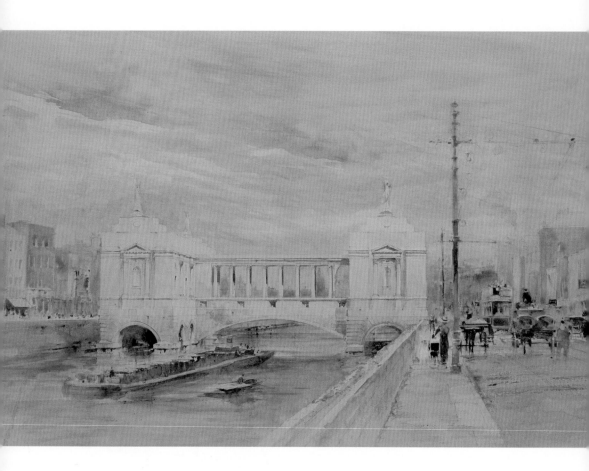

William Walcot
Proposed Bridge Gallery, distant front view, 1912

Gallery, as even if the permanent building promised immediately I want to take a considerable number of pictures I have collected for Dublin, but which have never been seen there for want of space. As I still hope my Gallery in Dublin will not prove a failure, I cannot think of giving them to any other gallery at present, but failing that, a loan of them for one or two years would appear to me quite unworthy of them as a gift. I confess to be quite out of synergy with the English National Gallery who seem only able to buy the dearest pictures on the market, and seem to be satisfied with a hopelessly old fashioned method.[17]

In September 1913, to the background of the Dublin lock-out, Hugh Lane removed his 'Conditional Gift' to London on loan to the National Gallery. By February 1914 it appeared Lane was regretting his decision. The Trustees of the National Gallery refused to hang all of his paintings, deeming only selected works fit to be exhibited. Lane was extremely annoyed as it put him in a bad light, giving credence to his detractors who believed his proposed gift of modern art to Dublin didn't merit the attention or public expenditure on a new building. In a letter dated 26 February to Lord Curzon, Chairman of the Board of the National Gallery, his fury can be felt. He begins by saying:

> I am sorry to hear you have forgotten the occasion when you came here and asked me to lend the Dublin Group of pictures to the N.G. … I am collecting all the dates and correspondence and can supply you with them later on… I am so very sorry that I allowed myself to be persuaded by you to write to Sir Charles [Holroyd, Director of the National Gallery] offering the loan… Unfortunately the offer of them has gone through at the N.G. puts me in a ridiculous position with Dublin, that I should be obliged to give it full publicity to get a fair judgement on the question.[18]

Lane had been appointed Director of the National Gallery of Ireland that month and no doubt he found it intolerable to have his judgement on pictures questioned by a committee in this way. He did concede that some of them may not be as significant as others, but the rejection of such works as Renoir's *Les Parapluies* and *Lavacourt under Snow* by Monet[19] by a committee of non-experts was for him unsupportable.

17 Hugh Lane to Lord Curzon, 8 August 1913, NLI, Ms 35,822 (1–30).
18 *Ibid.*
19 Previously titled *Vétheuil, Sunshine and Snow*, this painting had been rejected by the National Gallery when offered to them by Frank Rutter and D.S. McColl who, as members of the committee of the French Impressionist Fund, a public subscription fund set up for the purchase of French Impressionist paintings, offered the work following its exhibition at the Grafton Galleries in 1905.

The situation was unresolved when the following year, before departing for the US, Lane wrote the famous codicil to his will of 1913, returning the paintings to Dublin provided a gallery would be built within five years of his death. It was his desire that the whole collection would hang together. Hugh Lane died aboard the Lusitania which was torpedoed by a German U-boat off the coast of Cork in 1915. His codicil, which was signed but not witnessed, was found not to be legal under English law and his paintings remained in the ownership of the Trustees of the National Gallery, London, despite the establishment of the Tate Gallery of Modern Art in 1917. Following a series of agreements, the first in 1957 and the most recent in 2001, the paintings are now shared between London and Dublin.

While some of the works are undoubtedly among the finest exponents of modernist painting, the group is not a homogenous collection. They are like jigsaw pieces which only make sense when viewed in their overall context. The significance of the 'Lane Pictures' and an understanding of where they fit into Lane's vision can only be fully appreciated when they are exhibited alongside the rest of the collection he assembled for a Gallery of Modern Art for Dublin. In 2008, for the first time ever, as part of the Gallery's centenary celebrations, the entire collection was exhibited in Dublin from June to September. During that period, the picture was complete.

Installation view of *Hugh Lane 100 Years* (2008),
with (from left to right) *Hugh Lane* (1906)
by John Singer Sargent; *Les Parapluies* (c.1891–6;
The National Gallery, London) by Pierre-
Auguste Renoir; and *The Age of Bronze* (1877)
by Auguste Rodin

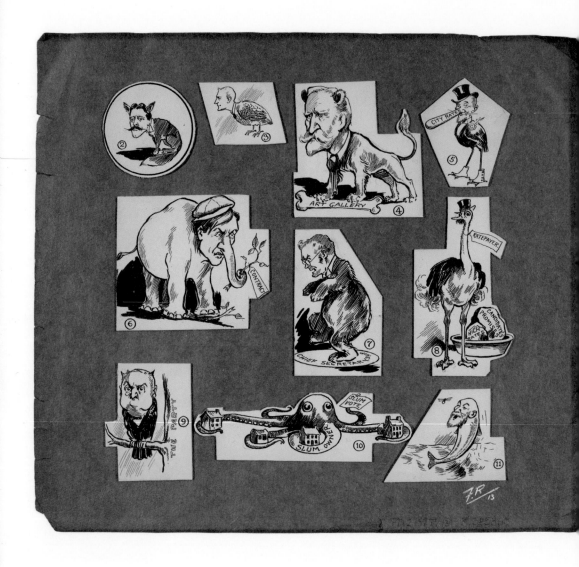

Frank Reynolds
In The Irish Zoo, December 1913
Ink and gouache on card, pasted on sheet,
31.3 × 35.2 cm
National Library of Ireland

The caricatures include: (2) Lorcan Sherlock, Lord Mayor, (3) Mr Partridge, (4) William Martin Murphy, (5) Charles Dawson, (6) James Larkin, (7) Augustine Birrell, Chief Secretary, (9) John Redmond.

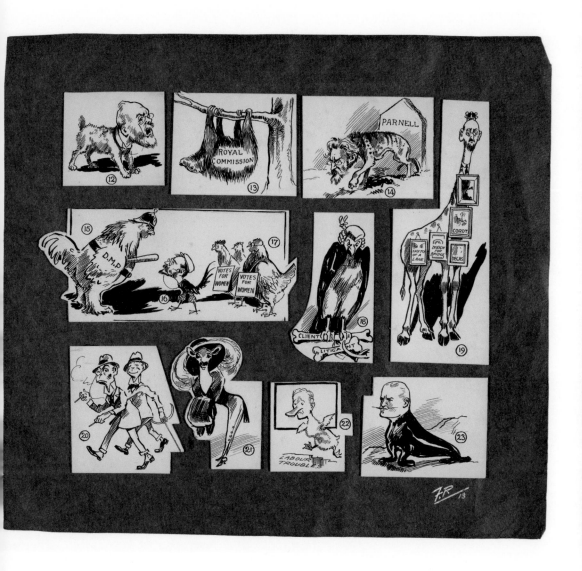

Frank Reynolds
In The Dublin Zoo, December 1913
Ink and gouache on card, pasted on sheet,
31.3 × 35.2 cm
National Library of Ireland

The caricatures include: (12) Tim Healy,
(14) William O'Brien, (16) Francis Sheehy
Skeffington, (19) Sir Hugh Lane, (22) Harry
Gosling, British National Transport Workers'
Federation, (23) Henry Campbell, Town Clerk.

Sir John Lavery
Sutton Courtenay, 1917

Artworks in the Exhibition

Sir Max Beerbohm (1872–1956)

*Mr W.B. Yeats Presenting Mr George Moore to
the Queen of the Fairies*
c. 1904
Ink on paper, 32.1 × 19.9 cm
Reg. 71
Lane Gift, 1912
p. 94

Sir Hugh Lane Producing Masterpieces for Dublin
1909
Ink and pencil on paper, 43.7 × 37.3 cm
Reg. 1033
Presented by J. Hugh C. Lane, 1952

Sir Hugh Lane Guarding a Manet
1911
Pencil on paper, 41.1 × 32.8 cm
Reg. 1034
Presented by J. Hugh C. Lane, 1952

Mina Carney (1892–1974)

Jim Larkin
n.d.
Bronze, 37.6 × 19.5 × 28 cm
Reg. 795
Presented by the Executive Committee,
Workers' Union of Ireland, 1937
p. 14

Mary Duncan (1885–1964)

James Stephens
c. 1915
Lithograph on paper, 29.2 × 22.9 cm
Reg. 1601
Presented by Katie Gliddon, 1956
p. 32

Jacob Epstein (1880–1959)

Lady Gregory
1910
Bronze, 36 × 35 × 28 cm
Reg. 98
Lane Gift, 1912
p. 96

Mary Grant (1831–1908)

Charles Stewart Parnell
1892
Bronze, 72 × 51 × 34 cm
Reg. 700
Presented by the Parnell Monument
Committee, 1933
p. 12

Robert Gregory (1881–1918)

Coole Lake
c. 1914
Oil on canvas, 66 × 91.5 cm
Reg. 104
Lane Bequest, 1913
p. 24

Sarah Cecilia Harrison (1863–1941)

Mr and Mrs Thomas Haslam
1908
Oil on canvas, 91.5 × 78.8 cm
Reg. 57
Lane Gift, 1912
p. 79

Portrait of the Artist
1900
Oil on panel, 22.3 × 17.5 cm
Reg. 233
Presented by Mrs Owen
p. 70, 81

Francis Sheehy Skeffington
1916
Oil on canvas, 58.7cm × 45.8 cm
Reg. 1315
Presented by Mrs Sheehy Skeffington, 1970
p. 83

Alderman Thomas Kelly
1925
Oil on canvas, 66.6 × 53.3 cm
Reg. 609
Presented by Sarah Cecilia Harrison
(the Artist), 1926
p. 77

Grace Henry (1868–1935)

Evening, Achill
1912
Oil on canvas, 58.5 × 49.5 cm
Reg. 1885
Purchased, 1995

Paul Henry (1876–1958)

My Friend Michael Mangan
1910–12
Oil on board, 15.7 × 10.9 cm
Collection Ulster Museum
Purchased 1974

The Potato Digger
1912–15
Oil on canvas, 35.2 × 46 cm
Collection Ulster Museum
Purchased 1993
p. 25

Seán Keating (1889–1977)

An Aran Fisherman and his Wife
1916
Oil on canvas, 124.5 × 99 cm
Reg. 660
Presented by W.G. Lyon, 1931
p. 23

Walt Kuhn (1877–1949)

Portrait of John Butler Yeats RHA
1917
Oil on canvas, 102.9 × 79.4 cm
Reg. 632
Presented by Cornelius Sullivan, 1927
p. 102

Sir John Lavery (1856–1941)

*Second Study for the King, the Queen, the Prince
of Wales, the Princess Mary, Buckingham Palace*
1913
Oil on canvas, 76.1 × 63.4 cm
Collection Ulster Museum
Donated by the artist, 1919
p. 61

Sir Winston Churchill
1915
Oil on canvas, 76.8 × 63.9 cm
Reg. 737
Lady Lavery Memorial Bequest through
Sir John Lavery, 1935

John E. Redmond, MP
1916
Oil on canvas, 76.2 × 63.6 cm
Reg. 251
Presented by Lieutenant-Colonel Sir William
Hutcheson-Poë in remembrance of Sir Hugh
Lane, 1917
p. 64

Sir Edward Carson, MP
1916
Oil on canvas, 76.2 × 63.6 cm
Reg. 252
Presented by Lieutenant-Colonel Sir William
Hutcheson-Poë in remembrance of Sir Hugh
Lane, 1917
p. 69

Sutton Courtenay
1917
Oil on canvas, 100 × 125 cm
Reg. 782
Presented by Count John McCormack, 1936
p. 118

His Eminence Cardinal Logue 1840–1924
1920
Oil on canvas, 79.1 × 64.1 cm
Collection Ulster Museum
Donated by the artist, 1919

Timothy Healy
1922
Oil on canvas, 89.5 × 71.1 cm
Reg. 729
Lady Lavery Memorial Bequest through
Sir John Lavery, 1935

David Lloyd George
1922
Oil on canvas, 76.2 × 63.6 cm
Reg. 735
Lady Lavery Memorial Bequest through
Sir John Lavery, 1935

Rt. Hon. The Viscount Craigavon 1871–1940,
First Prime Minister of Northern Ireland
1923
Oil on canvas, 91.5 × 71.1 cm
Collection Ulster Museum
Donated by the artist, 1929
Reg. T397
p. 34

William Cosgrave
1923
Oil on canvas, 91.5 × 71.1 cm
Reg. 740
Lady Lavery Memorial Bequest through
Sir John Lavery, 1935
p. 30

Joseph Devlin, MP 1871–1934
1928
Oil on canvas, 102.1 × 76.7 cm
Collection Ulster Museum
Donated by the artist, 1929
p. 30

Antonio Mancini (1852–1930)

Portrait of Sir Hugh Lane
1904
Oil on canvas, 226.1 × 116.8 cm
Reg. 148
Lane Bequest, 1913
p. 100

Count Casimir Joseph Dunin de Markievicz
(1874–1940)

George Russell (Æ)
1904
Oil on canvas, 60.9 × 50.8 cm
Reg. 51
Lane Gift, 1912
p. 58

Harold Oakley

J.M. Synge, W.B. Yeats and Æ Fishing from
a Boat
c. 1901
Pencil on paper, 21 × 13 cm
Reg. 1049
Presented by Justine Somerville Oakley, 1954

Dermod O'Brien (1865–1945)

Sheepshearing
c. 1901
Oil on canvas, 76 × 106 cm
Reg. 219
Presented by Dermod O'Brien (the Artist),
1904
p. 57

Alderman W.F. Cotton, MP
1910
Oil on canvas, 72.4 × 62.2 cm
Reg. 56
Lane Gift, 1912
p. 52

Sir William Orpen (1878–1931)

Lord MacDonnell, GCSI
1904
Oil on canvas, 74.9 × 62.2 cm
Reg. 43
Lane Gift, 1912
p. 36

Jabberwockky
c. 1905
Ink on paper, 18 × 13.5 cm
Reg. 173
Lane Bequest, 1913
p. 38

Enough!
c. 1905
Ink on paper, 32 × 19 cm
Reg. 174
Lane Bequest, 1913
p. 4

The Right Honourable Sir Thomas W. Russell, Bart.
1905
Oil on canvas, 73.6 × 62.2 cm
Reg. 42
Lane Gift, 1912
p. 44

William O'Brien, MP
1905
Oil on canvas, 75 × 62 cm
Reg. 45
Lane Gift, 1912
p. 45

Michael Davitt, MP
1905
Oil on canvas, 74.9 × 62.2 cm
Reg. 46
Lane Gift, 1912
p. 17

Rev. J.P. Mahaffy, DD, CVD, etc.
1905
Oil on canvas, 74 × 62.2 cm
Reg. 48
Lane Gift, 1912
p. 41

Portrait of the Artist
c. 1906
Oil on canvas, 74.6 × 59.4 cm
Reg. 230
Presented by William Orpen (the Artist), 1908
p. 27

Captain Shawe-Taylor
1906
Oil on canvas, 73.6 × 62.8 cm
Reg. 49
Lane Gift, 1912
p. 16

The Right Honourable Augustine Birrell, MP
1907
Oil on canvas, 113 × 85.1 cm
Reg. 50
Lane Gift, 1912
p. 53

Walter Frederick Osborne (1859–1903)

Colonel Maurice Moore
c. 1900
Oil on canvas, 68.6 × 58.4 cm
Reg. 253
Presented by Colonel Moore

Grace Gifford Plunkett (1888–1955)

Edward Martyn Having a Week of it in Paris
n.d.
Pen and ink on paper, 27 × 21.2 cm
Reg. 816
Presented by Joseph Holloway, 1937
p. 49

The Simple Life
1906
Watercolour and ink on paper, 31 × 27 cm
Reg. 1729
Cathleen Sheppard Bequest, 1986

Sarah Purser (1848–1943)

Miss Jane Barlow, D.Litt.
1894
Oil on canvas, 62.2 × 67.4 cm
Reg. 232
Presented by Mrs Barlow
p. 74

Miss Maud Gonne
1898
Pastel on paper, 43 × 27 cm
Reg. 927
Presented by the Friends of the National
Collections of Ireland, 1944
p. 29

Portrait of Edward Martyn
c. 1899
Oil on canvas, 76 × 62 cm
Reg. 595
Presented by Sarah Purser (the Artist), 1924

W.B. Yeats
c. 1904
Pastel on paper, 43 × 25.4 cm
Reg. 926
Presented by the Friends of the National
Collections of Ireland, 1944
p. 92

François-Auguste-René Rodin (1840–1917)

The Right Hon. George Wyndham, MP
1904
Bronze, 64 × 47 × 28 cm
Reg. 522
Presented by Auguste Rodin (the Artist), 1907
p. 46

George Bernard Shaw
1906
Marble, 59 × 47.5 × 28 cm
Reg. 534
Presented by George Bernard Shaw, 1908
p. 18

William Rothenstein (1874–1943)

Captain Stephen Gwynn, MP
1917
Paper, 29 × 18 cm
Reg. 361
Presented by William Rothenstein (the Artist)
in remembrance of Sir Hugh Lane
p. 33

Study for Portrait Drawing of Lennox Robinson
c. 1921
Paper, 22.3 × 15.9 cm
Reg. 704
Presented by William Rothenstein (the Artist),
1934
p. 87

George William Russell (Æ) (1867–1935)

The Log Carriers
c. 1904
Oil on canvas, 49.5 × 66 cm
Reg. 31
Lane Gift, 1912
p. 56

Oliver Sheppard (1864–1941)

Portrait Bust of John O'Leary
1903
Bronze, 67 × 34 × 30 cm
Reg. 570
Presented by the Artist; cast by Dublin
Corporation from the original plaster bust, 1923
p. 48

Boleslaw von Szankowski (1973–1953)

Countess Constance Markievicz
1901
Oil on canvas, 200.7 × 85.1 cm
Reg. 688
Presented by Count Markievicz and son, 1932
p. 75

Patrick Joseph Tuohy (1894–1930)

Flight of Cúchulainn
c. 1919
Paper, 28.6 × 18.4 cm
Reg. 912
Presented by Joseph Holloway, 1943
p. 21

Entry to Battle
c. 1919
Paper, 28 × 19 cm
Reg. 913
Presented by Joseph Holloway, 1943

William Walcot (1874–1943)

*First design for proposed Gallery of Modern Art,
St Stephen's Green*
1912
Watercolour on paper, 32.4 × 57.8 cm
Reg. 602
Lane Bequest, 1913

Proposed Bridge Gallery, distant front view
1912
Watercolour on paper, 50.7 × 79.8 cm
Reg. 201
Lane Bequest, 1913
p. 112

Leo Whelan (1892–1956)

William O'Brien
c. 1946
Oil on canvas, 76.2 × 61 cm
Reg. 1011
Presented by Irish Transport and General
Workers' Union, 1947
p. 62

Lily Williams (1874–1940)

Arthur Griffith
c. 1920
Oil on canvas, 76.2 × 63.5 cm
Reg. 231
Presented by Lily Williams (the Artist), 1922
p. 98

Jack B. Yeats (1871–1957)

The Rogue
1903
Watercolour on paper, 53.3 × 37 cm
Reg. 358
Presented by Jack B. Yeats (the Artist)

The Accordion Player
c. 1904
Watercolour on paper, 53.5 × 37 cm
Reg. 356
Presented by Jack B. Yeats (the Artist)

The Day of the Sports
c. 1904
Watercolour on paper, 37.5 × 53.4 cm
Reg. 357
Presented by Jack B. Yeats (the Artist), 1905

The Travelling Circus
1906
Watercolour on paper, 27 × 36 cm
Reg. 599
Bequeathed by Josephine Webb, 1924
p. 105

Evening
1907
Woodcut on paper, 20.3 × 30.5 cm
Reg. 1870
p. 105

An Old Slave
c. 1911
Pen, ink and watercolour on paper, 26 × 18 cm
Reg. 197
Lane Bequest, 1913
p. 22

John Butler Yeats (1839–1922)

Dr Douglas Hyde, LLD
c. 1904
Oil on canvas, 109.8 × 85 cm
Reg. 568
Presented by Miss Horniman
p. 92

Standish O'Grady
1904
Oil on canvas, 110.5 × 85 cm
Reg. 248
Presented by Standish O'Grady
p. 20

The Right Honourable Sir Horace Plunkett, KCVO
c. 1905
Oil on canvas, 76.2 × 64.8 cm
Reg. 41
Lane Gift, 1912
p. 90

John Millington Synge
c. 1905
Oil on canvas, 75 × 62.6 cm
Reg. 54
Lane Gift, 1912
p. 95

Handkerchief sold by The Abbey Players on their
American Tour to Raise Funds for a Building for
The Gallery of Modern Art
1913
Linen, 48 × 44.5 cm
Reg. 657
Presented by Mr Delaney, 1930
p. 28

Essayists

Prof. R.F. Foster is Carroll Professor of Irish History, University of Oxford.

Logan Sisley is Exhibitions Curator at Dublin City Gallery The Hugh Lane.

Prof. Michael Laffan is a recently-retired Professor of History at University College Dublin.

Dr Margarita Cappock is Head of Collections at Dublin City Gallery The Hugh Lane.

Dr P.J. Mathews is Lecturer, School of English, Drama and Film, University College Dublin.

Dr Barbara Dawson is Director of Dublin City Gallery The Hugh Lane.

Acknowledgements

*Revolutionary States: Home Rule and
Modern Ireland*

Dublin City Gallery The Hugh Lane
24 May to 21 October 2012

Curated by Logan Sisley

Dublin City Gallery The Hugh Lane team for
*Revolutionary States: Home Rule and Modern
Ireland*: Barbara Dawson, Logan Sisley,
Margarita Cappock, Michael Dempsey, Joanna
Shepard, Jessica O'Donnell, Peadar Nolan,
Liz Forster, Dolores Fogarty, Tim Haier,
Mary Keogh, Monika Keska, Sarah Johnston,
Elizabeth Wilms, Sarah Allen, Marysia
Wieckiewicz, Daron Smyth, Anthony Donegan,
Patrick Fitzgerald, Gerard Crotty, Jurgita
Savickaite, Simon Lawlor, Niall O'Connor,
Mary Broome, Christopher Ford, Derek
Sweeney, Peter Gannon, Veronica Heapes,
Mary Monaghan, Dorothy Doyle, Sarah Healy,
Breda Byrne.

Dublin City Gallery The Hugh Lane wishes to
thank The Department of Arts, Heritage and
The Gaeltacht, The Ulster Museum / National
Museums Northern Ireland, and the following
individuals who in various ways have helped to
bring this exhibition and publication together:
R.F. Foster, Michael Laffan, P.J. Mathews, Sue
White, Jane McCree, Louise Walsworth-Bell,
Jason Ellis, Genevieve Muinzer, Honora Faul,
Gary Haines.

Published by Dublin City Gallery The Hugh Lane on the occasion of the exhibition, *Revolutionary States: Home Rule and Modern Ireland*, 24 May to 21 October 2012

Image credits: Sir Max Beerbohm, *Mr W.B. Yeats Presenting Mr George Moore to the Queen of the Fairies* © Estate of Sir Max Beerbohm; Mina Carney, *Jim Larkin* © Estate of Mina Carney; Mary Duncan, *James Stephens* © Estate of Mary Duncan; Jacob Epstein, *Lady Gregory* © Estate of Jacob Epstein; Paul Henry, *The Potato Digger* © Estate of Paul Henry, IVARO, Dublin 2012; Seán Keating, *An Aran Fisherman and his Wife*, reproduced with the permission of the Estate of Seán Keating; Walt Kuhn, *Portrait of John Butler Yeats RHA* © Estate of Walt Kuhn; John Lavery, *Joseph Devlin, MP 1871–1934*, *Second Study for the King, the Queen, the Prince of Wales, the Princess Mary, Buckingham Palace*, and *Rt. Hon. The Viscount Craigavon 1871–1940, First Prime Minister of Northern Ireland*, images © National Museums Northern Ireland 2012; Letter from Sir Edwin Lutyens to Sir Hugh Lane, Ms 35,823/3/13(2), reproduced courtesy of the National Library of Ireland; Dermod O'Brien, *Sheepshearing* © Estate of Dermod O'Brien; Horace T. O'Rourke, 'A Suggestion for a Bridge Gallery of Modern Art for Dublin', reproduced courtesy of the Board of Trinity College Dublin; Grace Gifford Plunkett, *Edward Martyn Having a Week of it in Paris* © Estate of Grace Gifford Plunkett; Sarah Purser, *Miss Maud Gonne, Miss Jane Barlow*, and *W.B. Yeats* © Estate of Sarah Purser; Pierre-Auguste Renoir, *Les Parapluies*, reproduced courtesy of The National Gallery, London; Frank Reynolds, *In The Irish Zoo*, and *In The Dublin Zoo* © Estate of Frank Reynolds, reproduced courtesy of the National Library of Ireland; William Rothenstein, *Captain Stephen Gwynn, MP*, 1917 and *Study for Portrait Drawing of Lennox Robinson* © Estate of William Rothenstein / The Bridgeman Art Library; Boleslaw von Szankowski, *Countess Constance Markievicz*, 1901 © Estate of Boleslaw von Szankowski; William Walcot, *Proposed Bridge Gallery* © Estate of William Walcot; Leo Whelan, *William O'Brien* © Estate of Leo Whelan; Jack B. Yeats, *An Old Slave*, *The Travelling Circus*, and *Evening* © Estate of Jack B. Yeats. All rights reserved, DACS 2012; Photograph of Augustus Saint-Gaudens, *Model for Parnell Monument* (c.1905), reproduced courtesy of Saint-Gaudens National Historic Site, Cornish, NH; Photograph of The Municipal Gallery of Modern Art, Clonmell House, Harcourt Street, reproduced courtesy of The Irish Architectural Archive.

Every effort has been made to trace copyright holders, but if any have been overlooked inadvertently, the publishers will be pleased to make the necessary arrangements at the first opportunity.

Editor: Logan Sisley
Copy editor: Elizabeth Mayes
Designer: Tony Waddingham
Photography: Eugene Langan
Printed in Belgium by Cassochrome

ISBN: 978-1-901702-41-5

Dublin City Gallery The Hugh Lane
Charlemont House
Parnell Square North
Dublin 1
T: +353 222 5550
www.hughlane.ie

Baile Átha Cliath
Dublin City

Supported by:

An Roinn Ealaíon, Oidhreachta agus Gaeltachta
Department of Arts, Heritage and the Gaeltacht